PHOTOGRAPHER'S GUIDE TO

THE DIGITAL PORTRAIT

Start to Finish with Adobe® Photoshop®

AL AUDLEMAN

AMHERST MEDIA, INC. ■ BUFFALO, NY

Published by:
Amherst Media®
P.O. Box 586
Buffalo, N.Y. 14226
Fax: 716-874-4508
www.AmherstMedia.com

Publisher: Craig Alesse
Senior Editor/Production Manager: Michelle Perkins
Assistant Editor: Barbara A. Lynch-Johnt

ISBN: 1-58428-118-9
Library of Congress Control Number: 2003103028

Printed in Korea.
10 9 8 7 6 5 4 3 2 1

ACKNOWLEDGMENTS

As we progress in our ability to use Photoshop, most of us do not do so alone. It is very important to take advantage of those who came before you and who are willing to share their knowledge and talents. I tried to learn Photoshop on my own, using the tutorials available with the program. I tried to read and understand some of the available teaching material to no avail. I simply did not have the patience to work through the material due to the complex interaction of many Photoshop functions.

I took my first class from Eddie Tapp and Jane Conner-Ziser at the Georgia School of Professional Photography in 1997, and while I was initially overwhelmed, the basics they provided gave me the tools to finally learn Photoshop, and I was on my way. Thanks to both Eddie and Jane, I began teaching Photoshop at the beginning level in 1999. I owe a lot to both of them and consider them my friends and mentors.

Since then I have attended several photo-imaging seminars and have read many related books. I have frequented the Professional Photographers of America's (PPA) digital imaging conferences and the National Association of Photoshop Professionals' (NAPP) "Photoshop World" conferences. Those who have provided me the most usable information in the field of digital photography are Jim Divitale (a good friend of mine and wonderfully creative digital photographer out of Atlanta), Ben Willmore, Scott Kelby, Julianne Kost, and many others from the NAPP group, all of whom I met through the Photoshop World events. Both PPA and NAPP publish some very educational magazines that have helped me work my way through many problems. Respectively, these publications are *PEI* (Photo/Electronic Imaging) and *Photoshop User*.

TAKE ADVANTAGE OF THOSE WHO CAME BEFORE YOU AND WHO ARE WILLING TO SHARE THEIR KNOWLEDGE AND TALENTS.

I also owe a lot to my many students, particularly those special few who have continued to seek more knowledge about Photoshop, who keep asking questions and force me to not only keep up with the latest versions of Photoshop but to continually expand my knowledge base just to keep up with them!

Finally, a very special thank you to my friend and model, Madeleine Burke-Fanning, who is not only a great subject, but also a wonderfully talented watercolor artist and teacher.

As you strive to become more proficient in Photoshop, I recommend that you join and participate in those organizations—they will provide you with the support and education necessary to keep ahead of the curve. If you do professional-level digital imaging, then you need to emphasize the word "professional," and step up to that level in everything you do. Your clients expect and deserve exactly that. It is your responsibility!

EMPHASIZE THE WORD "PROFESSIONAL," AND STEP UP TO THAT LEVEL IN EVERYTHING YOU DO.

ABOUT THE AUTHOR

Al Audleman is a commercial photographer specializing in digital imaging. His studio is located in Pensacola, Florida, but he services clients nationwide. A former US Navy journalist and civilian public affairs officer for the Navy, he also served a stint in curriculum development in the Navy's Electronic Warfare program. His background in publication production led him to open his own business in 1978. He began by producing magazines and newsletters for various professional and recreational associations, and his training in photography paved the way for a change from publications to commercial photography shortly thereafter.

An early participant in digital imaging, Al began teaching Adobe® Photoshop® in 1999, specializing in instruction at the beginning level in an effort to get photographers up to speed in a very complex program.

AL IS THE RECIPIENT OF SEVERAL KODAK GALLERY AND FUJI MASTERPIECE AWARDS....

He is active in many professional organizations, including the Professional Photographers of America (PPA), Florida Professional Photographers, Georgia Professional Photographers Association, Professional Photographers of Mississippi/Alabama, the American Society of Media Photographers, Professional Aerial Photographers of America, American Advertising Federation, the National Association of Photoshop Professionals, and the Association of Independent Architectural Photographers. He is a PPA Certified Photographer and has earned the PPA Master of Photography and Photographic Craftsman designations. In 2002, he was recognized by PPA as one of the first Approved Photographic/Imaging Instructors.

His work has been recognized through PPA International and affiliated judging, and several of his images have been accepted into the PPA

Loan Collection and the Kodak Epcot Center Display. Al is the recipient of several Kodak Gallery and Fuji Masterpiece Awards, and he was named the Florida Professional Photographers Photographer of the Year in 2001 and 2002.

Al's client list includes several major corporations such as AT&T, WalMart, K-Mart, Target, Dow-Corning, the Whitlock Group, International Paper, Champion International, Holiday Inn Worldwide, Exxon, and Burton Golf. He has been published in numerous national magazines including *Sail, Boating, Motor Trend, Southern Living, Florida Trend, Popular Science, Shutterbug,* and *Blade.*

Now, as clients demand digital photography from professional photographers, his goal is to reach as many photographers as possible and provide them with a solid foundation of quality digital imaging—instruction in Photoshop.

AL'S CLIENT LIST INCLUDES SEVERAL MAJOR CORPORATIONS SUCH AS AT&T, WALMART, K-MART, AND TARGET ...

CONTENTS

INTRODUCTION

Introduced in the early 1990s, Adobe® Photoshop® quickly became the basis for all professional printing and digital imaging. By the mid 1990s, digital cameras hit the market and the revolution of professional and amateur photography began in earnest. Those who jumped on the bandwagon early in the game took the slings and arrows always allotted to pioneers and found very little support from most manufacturers and sales organizations. This group was a fraternity of digital imaging pioneers; they helped each other gain the knowledge and the ability to produce quality digital images.

Today, things have changed, and digital imaging/photography—like rock 'n' roll—is here to stay. Not only is it embraced by the professional photographic community, it is used by the amateur market as well. And as the amateur photographer embraces digital technology, there is a demand that the professional community adopt it too. Those of us who have moved into the arena pick up assignments from traditional film photographers because clients know that digital photography can be done much more quickly than film.

CLIENTS KNOW THAT DIGITAL PHOTOGRAPHY CAN BE DONE MUCH MORE QUICKLY THAN FILM.

That brings us back to Photoshop. Whether you capture your images using a digital camera or scan them from negatives or prints, Photoshop will still be the "glue" that holds your imaging together. There are a number of books about Photoshop on the market today. While most of the early published material was devoted to the graphic design side of Photoshop, many recent offerings have been geared toward the photographic community—however, much of it is devoted to high-end color management and creative composition techniques. Portrait and wedding photographers, who tend to prefer to create their artistry in-

camera, are not well served by such books. And most portrait customers don't want an overly creative image. They want the image to look like a photograph, and for that image to make them look as good as possible.

With film photography, once an image was captured on film, it was turned over to the lab, which processed the film, provided proofs, and often corrected poor exposures. If you are doing digital capture, you no longer have that luxury. Your exposures must be on the money. With digital capture, *you* are also the lab—and your computer, equipped with Photoshop, is the processor.

This book will walk you through the steps you need to take to finesse your images and ultimately output the best possible portraits. Photoshop offers users at least two and very often many more ways to accomplish any task. My objective in presenting this material to you is not just to get you from opening to finalizing each of your images, but to make them the best they can be—efficiently and proficiently. Time is money for all of us. As you become proficient using Photoshop, you will modify the techniques learned here to suit your specific needs.

While this book was written with users of Photoshop 7.0 in mind, there are only a few techniques dealt with in this book that are specific to that version. Since version 5.0 was released, Adobe has continually added more photography-based functions. I suggest that you have version 6.0 or higher if you are going to seriously work with Photoshop. If you're a professional imager, then having the latest version is important.

Now, let's try to make the learning curve a lot less steep and get you moving in the right direction.

1.
DIGITAL WORKFLOW

Photographers have long mastered the assignment-related workflow in a film environment, but things have changed with the advent of digital imaging. However, the requirement is still there to maintain an efficient and orderly flow of work. Like establishing a checklist to ensure that each and every task is completed for every job, establishing an orderly workflow and making sure that it is followed to the letter—by yourself *and* your employees—is of vital importance. Managing an efficient workflow is hard enough when you do it all yourself, but it is harder still when there are several people involved.

So, why does digital technology make it difficult to set up a consistent and organized workflow? One of the biggest problems is that digital files exist only as data. There are no hard copies of anything during the digital capture phase, and simply trying to keep file names straight, not to mention remembering exactly what has been done to each of those images can become very confusing. Going digital requires a different outlook—and a different production process. Don't worry—once you get the hang of it, utilizing this type of workflow will be second nature.

DON'T WORRY—ONCE YOU GET THE HANG OF IT, UTILIZING THIS TYPE OF WORKFLOW WILL BE SECOND NATURE.

This chapter presents an overview of the steps required to take your images from start to finish with Adobe Photoshop. The chapters that follow will expound on the information found here.

☐ AN OVERVIEW OF THE PROCESS

Image Sources. Before you do anything in Photoshop, you must import your images into the program. Whether these images are obtained from digital cameras, scanners, from photo CDs or DVDs,

from clients, or stock photo files, there are a few things that must be accomplished before you proceed.

The Initial Save. It is very important to retain the *original* image just in case you ever need to return to the beginning. This is your "negative." Regardless of whether the image is a JPEG, TIFF, or Raw file, save it on a CD/DVD in your client's file or in whatever system you use. This is a CYA—or Cover Your Assets—situation.

When you work on an image, the first thing you should do is Save As. At this point, you'll need to change the file to a Photoshop document (PSD file) and rename it your "working" file. If you consistently take these measures, you will always know that the working image is a PSD file, and you will always know which image you are looking at. When you deliver a client file, you should flatten the image if it has layers and convert it to either a JPEG or TIFF. You don't need to save it since you have both the original and corrected images.

Color Neutralization. Once you have saved the image and it is on your monitor, you are faced with the task of neutralizing the color and eliminating any overall color cast. Once a forbidding task with images from early digital cameras, this is now relatively simple. Chapter 5 will deal with how to do this task. If you are sending images to a lab for printing, check with them *before making any color or tonal corrections*. They may prefer to do this themselves so as to minimize any damage you may do to an image in Photoshop.

Retouching/Restoration. Once I have done my color work, then I proceed to the retouching phase (or restoration if that is necessary) by performing required corrections. That includes dust spotting, correcting skin and hair problems, adding new backgrounds, etc. I then save the image again, something that you should do on a regular basis.

Flattening and Sharpening. To maintain the most control and allow for maximum flexibility, be sure to save your retouched/restored image as a Photoshop document (PSD) file. However, you do not want to deliver a PSD file to a client because, if they do not have Photoshop, they will not be able to open it. If they do have Photoshop, then they can open it and screw it up.

When you're certain that your job is done, first flatten the image, save it as a TIFF or JPEG file (depending on what you are going to do with it—more on this on pages 21–24), then sharpen it based on size and resolution.

Cropping/Sizing. Now is the time to size the image (both in terms of its dimensions *and* resolution) to fit the immediate needs of the assignment. While you *can* do this in one operation by setting the

desired final height, width, and resolution in the Options bar for the Crop tool, I suggest that you use another method. Here is the current thinking on boosting the resolution in images: You are going to increase your resolution 10 percent at a time so that Photoshop's interpolation method will maintain the highest image quality. Go to Image>Image Size then click on the box that says "Pixels" and change it to "Percent." It will say 100. Change it to 110 and click OK. This will increase the image size 10 percent at a time. Turn this into an action and you can "res up" your images significantly with minimal loss of quality. Then you can crop your image to the desired size. I suggest doing this as the last step in the process of delivering an image to either a lab or client—and not saving it since you can redo it whenever necessary—if necessary. Why take up the storage space? And with the working document on file, you can always go back to work on the image.

TURN THIS INTO AN ACTION AND YOU CAN "RES UP" YOUR IMAGES SIGNIFICANTLY WITH MINIMAL LOSS OF QUALITY.

Filing and Output. The last step in the digital workflow is the filing of images for easy retrieval, and the output—whether done in-house or by a lab—of your images. While the method you choose to file your images is a personal decision, your output requirements will vary based on the manner in which your portraits are generated. For more information on these topics, see chapter 13.

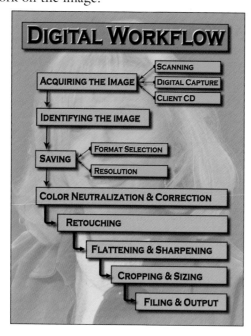

2.
OPENING YOUR IMAGES

☐ IMAGE SOURCES

Before you can begin working in Photoshop, you must somehow acquire digital files. There are many ways in which this can be accomplished. To determine which method is right for you, let's take a look at your image sources.

Digital Capture. If you are shooting with a digital camera, you already have digital files. All you will need to do is transfer them into your computer. This can be accomplished in one of two ways:

1. Upload them from the camera to the computer through the dedicated software available with most professional cameras.
2. Bring them directly into Photoshop and begin the workflow process immediately.

Film Photography. If you are a film photographer, you can still create digital image files. Where do these files come from? Well, there are several options:

1. Some labs will provide you with scans of your negatives. Many professional labs can provide high-resolution scans in the 60-megabyte range. Most amateur labs now also provide low-resolution scans on CD. Any of these can be opened in Photoshop.
2. You can purchase a film scanner and scan your own negatives. The cost of this device can range from less than $1,000 to several thousand dollars.

BEFORE YOU CAN BEGIN WORKING IN PHOTOSHOP, YOU MUST SOMEHOW ACQUIRE DIGITAL FILES.

3. You can have your lab make prints, which you can scan on your flatbed scanner. (You can now purchase one for less than $200, but the bad news is that, very often, price is indicative of quality).

◻ OPENING YOUR IMAGES IN PHOTOSHOP

Once your film images have been made into digital files, you'll need to open them in Photoshop so that you can begin to retouch them. There are three ways in which this can be done:

The File Browser. To view the File Browser, click on the File Browser palette tab in the palette well (see fig. 2.1); (*Hint:* Your screen resolution must be set to at least 1024x768 pixels to see this palette well!) or go to File>Browse (see fig. 2.2); or use the keyboard shortcut Shift+Cmd/Ctrl+O ("Oh"—not zero). Any of these operations will cause a dialogue box containing four "panes" to appear, and you will see the hierarchy of files in the upper-left panel. This is called the tree pane (see fig. 2.3). Click on the folder that contains the image(s) you wish to

ONCE YOUR FILM IMAGES HAVE BEEN MADE INTO DIGITAL FILES, YOU'LL NEED TO OPEN THEM IN PHOTOSHOP …

NOTICE TO READERS

You will find several time-saving keyboard shortcuts listed throughout this book. Where the Mac and Windows keystrokes differ, they will be noted as "Cmd/Ctrl" or "Opt/Alt" plus the appropriate additional keystroke(s) for the tool. If you are working on a Macintosh, you will use the Command (⌘) or Option key. If you are working on Windows, you will use the Control or Alt key.

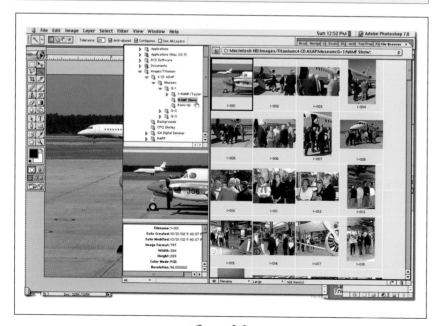

figure 2.1

open, and the thumbnail pane on the right will show your selected images and/or folders. As the specific file you wish to open may not be readily visible, you may need to click on the folder that appears in the thumbnail pane to open it, view its contents, and find your file.

You can also change the size of the thumbnail in this window for better visibility by clicking on the box located in the center of the bottom of the palette (the box may currently be labeled "Medium," "Small," "Details," etc., depending on the preference that is currently selected; see fig. 2.4 on page 18). The size of each pane can also be changed for better visibility—just click the pane's border and drag it up or down, right or left.

THE SIZE OF EACH PANE CAN ALSO BE CHANGED FOR BETTER VISIBILITY—JUST CLICK THE PANE'S BORDER AND DRAG IT.

File	Edit	Image	Layer	S⟩
New...				⌘N
Open...				⌘O
Browse...				⇧⌘O
Open Recent				▶
Close				⌘W
Close All				⌥⌘W
Save				⌘S
Save As...				⇧⌘S
Save for Web...				⌥⇧⌘S
Revert				
Place...				
Import				▶
Export				▶
Workgroup				▶
Automate				▶
File Info...				
Page Setup...				⇧⌘P
Print with Preview...				⌘P
Print...				⌥⌘P
Print One Copy				⌥⇧⌘P
Jump To				▶
Quit				⌘Q

figure 2.2

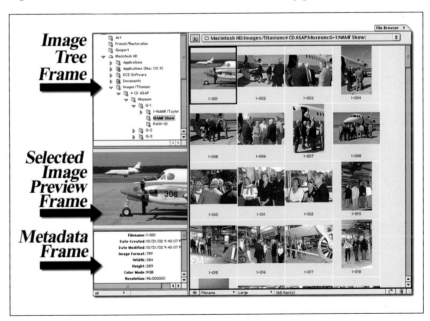

figure 2.3

On the left side of the box are the "preview pane," in which the selected image will appear before it is opened in Photoshop, and the metadata pane (see fig. 2.5). The metadata pane contains information provided by a professional digital camera, including file names, exposure data, lens data, and much more. This information will become more and more useful in the digital world as digital technology progresses.

THE METADATA PANE CONTAINS INFORMATION PROVIDED BY A PROFESSIONAL DIGITAL CAMERA....

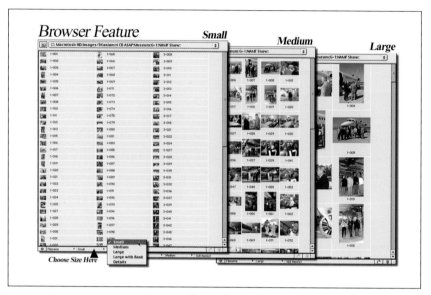

figure 2.4

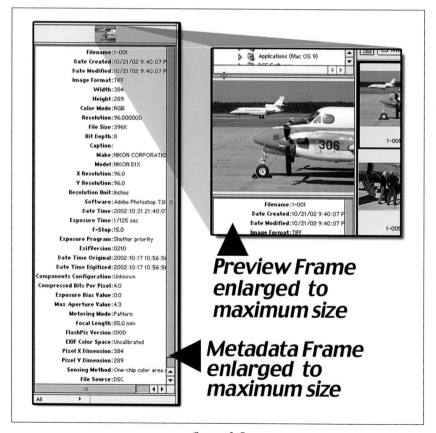

figure 2.5

When you've located the desired file, click on it, then hit Enter—or double click on it instead—and it will open in Photoshop. If you want to open multiple images, you have two choices: 1) to open many sequential images, click on the first one and the hold the Shift key

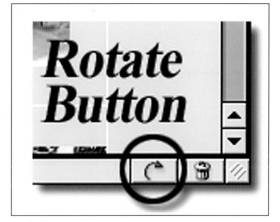

figure 2.6

down as you click on the last file you wish to open. All images in between the first and last will be selected; 2) To open several random images (in other words, to select images in a non-sequential order), click on the first one, then hold the Cmd/Ctrl key as you click on each additional image that you wish to open.

From the File Browser, you can also make some minor changes to your images. To rotate a photograph 90 degrees clockwise prior to opening it in Photoshop, click on the curved arrow at the lower-right corner of the dialogue box (see fig. 2.6). To rotate the image 90 degrees counterclockwise, hold down the Opt/Alt key and click on this same icon. If you prefer to use drop down menus, you can select a 90 degree rotation (either clockwise or counterclockwise) or rotate the image 180 degrees clicking on the upper-right corner of the dialogue box. Rotating your images in the File Browser is faster than opening them in Photoshop and then rotating them.

File>Open. Here is a very straightforward but slow way to open your images in Photoshop. First, open Photoshop, then go to File>Open and navigate through the drives and folders in the pull-down menu until you find the one on which your images are stored. When you find the file(s) you are looking for, highlight the image(s) you want to open and click OK.

The Click and Drag Option. If the folder containing the images you wish to use is already open, you can highlight the image(s) by clicking on it (and holding the Shift key, click on them all) and then drag them directly to the Photoshop icon on your desktop.

ROTATING YOUR IMAGES IN THE FILE BROWSER IS FASTER THAN OPENING THEM IN PHOTOSHOP....

◻ COLOR MODES

The effects outlined in this book should be made to images in the RGB color mode. If you are using images from a digital camera or images that you have scanned, your files will automatically be in RGB. (To ensure that this is the case, just go to Image>Mode.) In this mode, you can create a wide variety of corrections and enhancements, some of which are not available in other modes. If your image is in another mode, you can convert it to RGB, make your corrections, then reselect your preferred mode.

3.
FILES, FORMATS, AND RESOLUTION

☐ SAVING FILES

Saving your images is critical, and there are several decisions that you must make before doing so. Initially, these considerations may seem somewhat overwhelming, but saving images will become second nature in short order.

Save options include: Save, Save As, and Save for Web. You will note that the Save As and Save for Web options are followed by three dots. These dots indicate that when you select this option, you will be presented with a dialogue box that offers additional options. These three dots follow many of the options and tools in the pull-down menu in Photoshop, allowing you to direct the way in which Photoshop processes your images (see fig. 3.1).

File>Save. The Save option can create some problems if you are not careful, as you can easily alter your image with the click of a but-

SAVING YOUR IMAGES IS CRITICAL, AND THERE ARE SEVERAL DECISIONS THAT YOU MUST MAKE BEFORE DOING SO.

File	Edit	Image	Layer	Se
New...				⌘N
Open...				⌘O
Browse...				⇧⌘O
Open Recent				▶
Close				⌘W
Close All				⌥⌘W
Save				⌘S
Save As...				⇧⌘S
Save for Web...				⌥⇧⌘S
Revert				
Place...				
Import				▶
Export				▶
Workgroup				▶
Automate				▶
File Info...				
Page Setup...				⇧⌘P
Print with Preview...				⌘P
Print...				⌥⌘P
Print One Copy				⌥⇧⌘P
Jump To				▶
Quit				⌘Q

figure 3.1

ton. It is a good idea to create a backup file of an original image, and work from that file just in case the retouching doesn't go as planned.

If you create a new file (not an existing image!), the Save option works a bit differently. When you click Save, the Save As dialogue box will appear (see fig. 3.2). Here you will name the new file, select a file format, and even create a new folder in which to put it. You can also choose to save a copy of it. Keep in mind that once the initial Save selection is made, and you have dealt with the options in the Save As window, all subsequent Save requests for the file will allow you to simply save the image—no questions asked.

DO YOURSELF A FAVOR: AS SOON AS YOU OPEN YOUR ORIGINAL IMAGE, USE THE SAVE AS OPTION TO CREATE A BACKUP FILE....

Warning: As mentioned earlier, making corrections to an original image is never a good idea. When you use the Save shortcut, you bypass the Save As option and can thus apply irreversible changes to your original image. Do yourself a favor: As soon as you open your original image, use the Save As option to create a backup file—i.e., one that you can safely work on without destroying the original file.

The Save option (Cmd/Ctrl+S) will be available (not grayed out) in two circumstances:

1. When you open a new file (not an existing image), do some work on it, and have not yet named and saved it.
2. After you open an existing image and do something (anything) to it—like making color corrections, cropping, or retouching, for example.

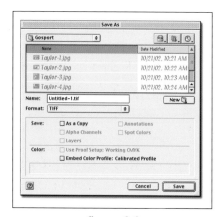

figure 3.2

File>Save As. Selecting this option after manipulating an image in some way allows you to rename the file (save a copy of the image). As mentioned earlier, its use is critical; when you open an original image, use this option to rename the file. Doing so will create a new file, which you can save into another folder to be doubly safe.

Again, when you select this option, you will need to make the same choices you made when you saved the image for the very first time (see fig. 3.3). *Every time* you select this option, you will be presented with two other dialogue boxes, each containing various options. These options will help you to customize various aspects of your image (i.e., the file name or the file format [more on this on pages 26–30]) to suit your specific needs.

File>Save for Web.
The final choice is Save for Web. This is an important option for those who send images via e-mail or post them on a website. In figure 3.4, you will see that the Save for Web dialogue box offers you a variety of options, only some of which will be covered here.

figure 3.3

THIS IS AN IMPORTANT OPTION FOR THOSE WHO SEND IMAGES VIA E-MAIL OR POST THEM ON A WEBSITE.

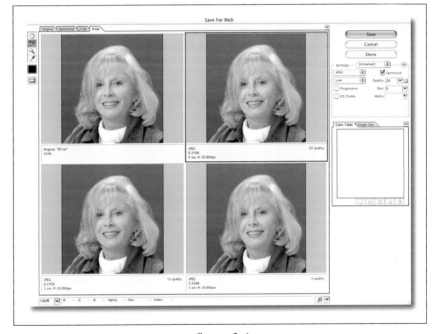

figure 3.4

First, because large images with high resolutions and happy prospective viewers do not go hand-in-hand, you will need to size your image before selecting Save for Web. To do this, go to Image>Size, enter the desired height and width dimensions, set the resolution to 72 ppi, and hit OK. (For more information on resolution requirements, see pages 24–26.) I suggest not sending anything larger than 8x10 inches, preferably smaller depending on the content of the image.

With this accomplished, go to File>Save for Web (see fig. 3.4) and click on the tab that says 2-Up when the dialogue box opens. This will show you the original image and the "optimized" image (see fig. 3.5).

When an image is destined for the web, select the JPEG option from the pull-down menu in the Settings column on the right side of the dialogue box. This format compresses the file and throws away non-essential data, allowing the large amount of digital information contained in an image to be easily transmitted through e-mails, and quickly loaded onto the web. (We'll go into more detail on file formats in the following chapter.)

Next, enter a figure from 1 to 100 in the box labeled Quality. If you prefer, you can click on the arrow on the right and use the dynamic slider to adjust the image until you are happy with the "optimized" quality. I have found that 60 works well for higher quality and 25 is fine for e-mail use where quality is less of a consideration than upload/download speed. When you've made your selections and are happy with the results, click OK, and save the file to the desired folder or drive.

60 WORKS WELL FOR HIGHER QUALITY AND 25 IS FINE FOR E-MAIL USE WHERE QUALITY IS LESS OF A CONSIDERATION....

☐ RESOLUTION REQUIREMENTS

Resolution refers to the density of pixels in an image. When there are a large number of pixels in one inch of the image, the image is said to be high resolution. On the other hand, when there are less pixels in that inch of the image, it is said to be a low resolution photograph. Since pixels are tiny bits of information that help shape an image, the higher the resolution, the better the quality of your image will be—to some extent. We'll get to that in a minute.

So, when it comes to selecting an appropriate resolution, what are your choices? For the most part, 300 ppi is as high a resolution as you

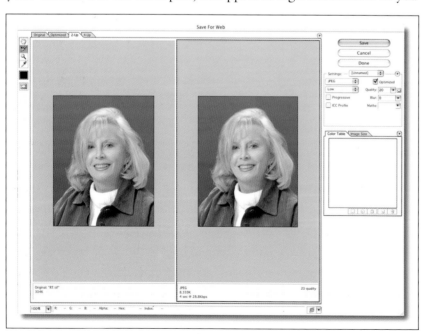

figure 3.5

will ever need. However, images for web or e-mail use—those that will be viewed on a computer screen—should have a resolution of 72–96 ppi, as too much data just takes too long to load, and your monitor is designed for this type of viewing (Macintosh monitors are 72 ppi and high-end PC monitors are 96 ppi).

Let's consider a hypothetical example that will help you make decisions on correct resolutions. Question: If you print a wallet-size print and a 20x30 from the same image, which file needs the higher resolution (pixels per inch)? Let's consider the eye of our subject in this case. In the 20x30-inch print, the eye will be approximately one-inch wide. In the wallet, it will be about one-tenth of an inch wide. The wallet print will need to to have more pixels to define detail in the eye!

Too Much of a Good Thing? If high resolution equals high quality, then why not produce images with fantastically high resolutions? Well, because you most likely will not be able to see an improvement in image quality once your image is more than 240 ppi. Most desktop printers are capable of producing prints at a very high dpi (in the 1440 range), but if you can't see an improvement in image quality, why deal with images that are that large? I suggest that your initial images be saved in their high-resolution form at 300 ppi for a couple of reasons: (1) Most service bureaus, should an image even need to be printed by a printing shop, require that your image have a resolution of 300 ppi; and (2) Printing presses require twice the ppi resolution as their printing "lpi," as outlined in the following paragraph.

Lines per Inch. If you are dealing with images for reproduction in printed media such as newspaper or magazines, you'll encounter another important resolution term: lines per inch, or lpi. To achieve the required lpi, simply make sure that your resolution is set to an amount equal to double that amount of pixels per inch. Therefore, since most newspapers print at an 85–100 lpi, you should set your image resolution to 170 to 200 ppi. Because high quality magazines usually print at 150 lpi, such publishers would require that your image have a resolution of

MOST DESKTOP PRINTERS ARE CAPABLE OF PRODUCING PRINTS AT A VERY HIGH DPI (IN THE 1440 RANGE)....

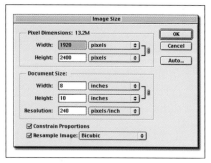

figure 3.6

300 ppi. Of course, your own publisher/printer may have different guidelines. To make sure that your image will meet their criteria, get their lpi requirements.

Setting Image Resolution. To set or change the resolution of your image, go to Image>Image Size (see fig. 3.6) and enter a resolution in the box. You can also change the image size in this dialogue box. (Clever that it is called Image Size, huh?) Before you do so, however, you must determine whether the pixels should be resampled, and whether or not you wish to change the proportions of your image.

In the image size dialogue box, you will see a Resample Image check box. With this box checked, the total number of pixels in your image will change if you change the height/width. However, if you uncheck the Resample Image box, you will see that adjusting the height/width will result in a corresponding change in the resolution (i.e., the image may be defined as having more or less pixels in each inch, but none will be added or eliminated).

There is also a Constrain Proportions check box in this window. With this box checked, any change you make to the height of the image will result in a corresponding change to the width (and vice versa). This ensures that your image will retain its original proportions (after all, a portrait might look a little funny if you change the height to ten inches, and leave the width at two inches!). At this default setting, you will see that the Height and Width boxes are chained together (linked); this visual cue lets you know that changing one dimension will affect the remaining dimension. With the box unchecked, you can change either dimension independently of the other, producing a distorted image.

AN IMAGE FORMAT IS A SPECIAL "LANGUAGE" USED BY A FILE TO TELL VARIOUS APPLICATIONS THAT YOUR IMAGE IS A PICTURE FILE.

☐ IMAGE FORMATS

An image format is a special "language" used by a file to tell various applications that your image is a picture file. It also tells that application how the data should be handled so that it is correctly displayed on your monitor. The file format is indicated by an extension (sometimes referred to as a "tag"), which appears after the file name.

When you save your file, you likely have a particular use for that image in mind, and you will need to select a file format that works for your recipient—whether the ultimate destination for the image is your

friend's online inbox or a commercial lab. So what are your choices and when should you choose what? Let's look at all the options in Photoshop (see fig. 3.7).

Photoshop (.psd). This is the do-it-all format. Also called the "native format," this option allows you to save all of your layers, effects, color and alpha channels, and paths. It also performs a non-lossy compression, which means that there is no image quality degradation with multiple saves. The downside to this format is that it cannot be opened by many other applications (it is compatible with some Adobe applications and a few other programs, such as Corel Painter®).

BMP (.bmp). The real name is "bitmapped," not to be confused with Photoshop's Bitmap mode for black & white images. Bitmapped images are normally used for graphics on a Windows platform.

CompuServe GIF (.gif). Shown only as a GIF without the CompuServe prefix, this is another popular file format for the web. Mostly used for nonphotographic images, you must first convert to the Indexed Color mode before saving. It is best for buttons, backgrounds, and other low-quality applications. The best thing about GIF images is that this format allows for transparency on the web, whereas JPEGs do not. Transparency allows you to eliminate a background in an image so it does not cover or interfere with other text or images.

Photoshop EPS (.eps). Shorthand for Encapsulated PostScript, this format is used for creating graphics for output on a PostScript® device, laser printer, imagesetter, etc., when using an illustrative or page-design program. The primary benefit of the EPS format is that it allows you to include (embed) a clipping path in the file. This allows you to hide backgrounds (i.e., makes them invisible so they do not print). The major problem with this format is that the images are low quality when you use them in programs such as PageMaker®, InDesign®, or QuarkXpress®. These files are also usually larger than other file formats, like PSD.

JPEG (.jpg). Once upon a time, a group of people got together, called themselves the Joint Photographic Expert Group, and developed this compression format to save cyberspace (no, not

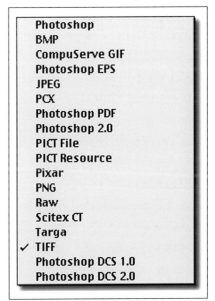

figure 3.7

...THIS OPTION ALLOWS YOU TO SAVE ALL OF YOUR LAYERS, EFFECTS, COLOR AND ALPHA CHANNELS, AND PATHS.

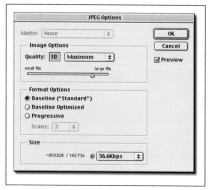

figure 3.8

like Captain Kirk—just saving final file size space!). JPEG images are normally used for web images or transmission via e-mail and contain many more colors than a GIF image. This is a compression format, which allows the computer to throw away nonessential data. (For this reason, JPEGs are also used by digital cameras to save space on storage media yet retain a high quality image.) When you save an image as a JPEG file, you are given a choice as to the quality: the higher the number, the less compression that occurs. At the low end, this format compresses the image as much as 100 times! (See fig. 3.8.)

The downside to a JPEG image is that it is a "lossy" format, and each time you open and resave a JPEG image, it loses quality by compressing the image and throwing away more data. You *do not* want to save a file over and over again in a JPEG format because you will lose a lot of quality eventually. This does not mean simply opening and closing a file, but opening and making changes, then saving it again.

PCX (.pcx). This is an older format that is used mainly by IBM PC-compatible computers. It is most often used by PCs running an early version of DOS and a paintbrush application; its application is limited for most users today.

Photoshop PDF (.pdf). Adobe's Portable Document Format is touted to be the format of the century; it is the standard for distributing documents with a lot of graphics, mostly via e-mail attachments. Images converted to the .pdf format can be opened with Adobe's Acrobat Reader® (if it is not readily available on your system, you can download it for free from Adobe's website).

Photoshop 2.0. Well, this one is pretty self-explanatory and, quite honestly, has limited applications. Those people still running Photoshop 2.0 can open an image created in a later version. This format does not use a file extension name.

PICT File (.pct). PC users can forget this one. It is a low-resolution Mac-only file and can only be viewed on a computer screen. It is mostly used in video-editing applications. For example, the images in this tutorial were originally "captured" using Apple's screen capture feature, which saves the captured files in the PICT format.

PICT Resource (.pct). This .pct format is Mac's version of the Windows BMP format discussed above. Its best use is saving a file that

YOU DO NOT WANT TO SAVE A FILE OVER AND OVER AGAIN IN A JPEG FORMAT AS YOU WILL LOSE A LOT OF QUALITY EVENTUALLY.

you want to use as a desktop pattern. Note that this format is for Mac users only.

Pixar (.pxr). Pixar is a very high-end animation workstation, and this format is designed for that particular use. FYI, the animated movie *Finding Nemo* was created by the Pixar studio.

PNG (.png). This non-lossy compression format is used for creating web graphics, but it has yet to gain much acceptance in that world. PNG stands for Portable Network Graphic.

Raw (.raw). The creators of Photoshop have thought of everything. This is a supposedly wonderful format designed to open files that are not normally supported by Photoshop. It uses the extension .raw which is, however, best applied to oysters and sashimi because I know of no one that has ever gotten a file to open by using this format. Oh well, best laid plans . . . *Note:* This is *not* the same as the raw files produced by professional digital cameras.

Scitex CT (.sct). Scitex ruled the digital world prior to Photoshop, and the name was synonymous with digital manipulation in the 1980s. Need to fix something? Just Scitex it out! Use this format only if you are going to send an image to a Scitex workstation, if you can find one anymore.

Targa (.tga). This is a "save when asked" format. When asked by whom? Well, by videographers using linear editing systems such as TrueVision®. It was also used by some older graphic systems outputting to film recorders.

THE TAGGED IMAGE FILE FORMAT IS THE MOST WIDELY-USED FORMAT SUPPORTED BY BOTH WINDOWS AND MAC COMPUTERS.

TIFF (.tif.). The TIFF, or Tagged Image File Format is the most widely-used format supported by both Windows and Mac computers. This format is even supported by non-imaging software such as Microsoft Word® and WordPerfect®. It offers lossless compression, now actually saves layers, and is probably the safest

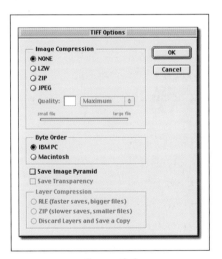

figure 3.9

choice for exporting to other applications, except for the web and e-mail, where the greater compression of the JPEG format makes it easier to send and receive messages. Figure 3.9 shows that you have a choice of IBM PC or Mac byte order and various compression formats. For the most part, check IBM PC byte order, and do not check the compression options.

Hint: If you are going to give someone an image in a TIFF format for use in another application, make sure you flatten it and delete all alpha channels and saved paths before you save it and give it to them. Otherwise, they will tell you that the image could not be opened.

Photoshop DCS 1.0 (.eps). Literally a Desktop Color Separation format that separates CMYK (not RGB) images into five separate files: one each for cyan, magenta, yellow, black, and a preview version of your image that is used by page layout programs such as PageMaker and QuarkXpress. It is actually an EPS format, but it has the advantage of making output from an imagesetter much faster—usually. It is also called a "five-part EPS" at some service bureaus.

Photoshop DCS 2.0 (.eps). Simple! It's a new and improved version of DCS 1.0, right? Nope! Though it is another EPS format, it is used only for creating spot colors. If you don't create spot colors, don't use this format.

4.
SETTING PREFERENCES

In order to make Photoshop work the way you want it to—*consistently*—you need to first set up your preferences. To view or alter your preferences setup options, go to Edit>Preferences (see fig. 4.1) and go right down the line.

▣ PERSONALIZING YOUR SOFTWARE

Preferences>General. A good place to begin is the beginning, so let's start with the General preferences setup (see fig. 4.2). While most of the default settings are perfectly fine, you may want to select some of the additional options found in the Options section. For instance, if you want your computer to beep when Photoshop completes a job, check that box. I also suggest that you make sure the Dynamic Color

figure 4.1

SAVING YOUR PALETTE LOCATIONS IS IMPORTANT, PARTICULARLY IF YOU ARE USING TWO MONITORS....

Sliders box and Save Palette Locations options are checked. Saving your palette locations is important, particularly if you are using two monitors and don't want to reposition your palettes every time you open Photoshop. In version 7.0, we also have the option of saving our workspace (Window>Workspace>Save Workspace) so we can set up different workspaces for different types of work; this is another option you might want to consider.

figure 4.2

I prefer to select the Use Shift Key for Tool Switch option. What does it do? Well, some of the tool icons in the tools palette feature little arrows, which indicate that other, similar tools can be accessed by clicking on the arrow and dragging your mouse slightly to the right. For example, if the visible icon for the Marquee is the rectangular tool, you could click on the arrow then select the elliptical Marquee. If you have *not* checked the Use Shift Key for Tool Switch option, you can toggle between all available tools located in a single area by clicking on its keyboard shortcut. In this case, using the keyboard shortcut "M" (the keyboard shortcut appears in the right-hand side of the menu that pops up when you click on the arrow) will select a new tool. Since you can access multiple tools through a single tool icon in some cases, you can use the appropriate keyboard shortcut to toggle through each of the available tools. Every time you click the required key, you'll move on to the next available tool.

The Reset All Warning Dialogs box located at the bottom is self-explanatory.

Note: The General preferences box also contains a field that allows you to select the number of history states you want Photoshop to display in the history palette. This also automatically sets the number of steps you can go back and undo. Some gurus say seven is enough. The default is twenty. It is true that the higher the number, the more RAM you will use because this is where the data for each history state is stored. But I have lots of RAM and a track record of needing to go back a long way at times, so I set it at 100 and it doesn't seem to affect my speed that much. It's your call!

…YOU CAN TOGGLE BETWEEN ALL AVAILABLE TOOLS LOCATED IN A SINGLE AREA BY CLICKING ON ITS KEYBOARD SHORTCUT.

Preferences>File Handling. Next, you should set your preferences for file handling (see fig. 4.3). While there are several options available in this dialogue box, the choices are relatively simple. First, you'll want to find the Image Previews pull-down menu, and select Always. Below this, you'll find the Append File Extension menu. If you select Always, Photoshop will add a file extension to your file name each and every time you save your file. This way, you will know what type of format you're dealing with whenever you see that file—be it on a CD, a Zip disk, or in a folder. This will help you keep track of your files. PCs do not give you the option of not allowing file extensions and therefore automatically add them to your file names.

I would also suggest you check the box under the File Compatibility section to Always Maximize Compatibility for Photoshop (PSD) Files. This seems like a no-brainer—unless, of course, you know someone who has an older version and you don't want them to open your files for some reason.

Leave the default Enable Workgroup Functionality checked for the time being.

The last option in this dialogue box allows you to select the number of files the Recent file list contains: I entered 10 because I often go back through several recent files after I have closed them. You make your own choice here. You might want more for commercial applications, less for portrait/retouching usage. Regardless of what you pick, like lenses for your camera, there will be times when you wish you had more. So go back and reset it. No problem!

figure 4.3

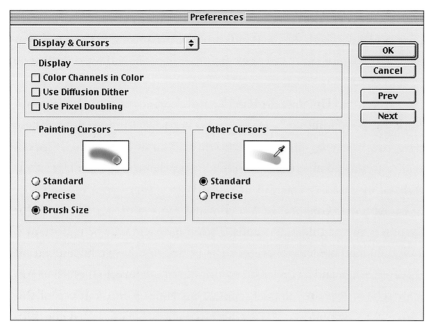

figure 4.4

Preferences>Display & Cursors. The third option is the Display & Cursors preferences (see fig. 4.4). I would suggest leaving the first and third boxes *unchecked*, particularly the first one—Color Channels in Color option. It is hard to see and work with the color channels if they are not in the grayscale mode. However, some people prefer to show the channels in color. Leave it alone now and redo it later if works better for you. Check the box Use Diffusion Dither because it helps smooth out the "jaggies" in your image.

Next, you'll see your cursor options—and these are important! Under Painting Cursors, you have three options: Standard, Precise, or Brush Size—select Brush Size, as your cursor will match the brush size you've selected, allowing you to see how much area you are affecting when painting or rubber stamping. In the Other Cursors section, select Standard. Standard mode gives you an icon depicting the tool. The Precise cursor is a crosshair that allows for a very precise positioning of your tools. It sounds like having the cursors set on Precise at times would be important, doesn't it? Well it is—and, even if you select Brush Size in the Preferences dialogue box, you can easily access the Precise cursor; simply hit the Caps Lock key and all cursors will change to Precise. But when you forget to unlock it or simply hit that key by accident, which you will, you will panic because you can't get the cursor to give you a brush size. After a couple of panic attacks, you will remember that somehow you hit the Caps Lock key, and when you hit it again, the standard brush size icon will return.

IT SOUNDS LIKE HAVING THE CURSORS SET ON PRECISE AT TIMES WOULD BE IMPORTANT, DOESN'T IT? WELL, IT IS.

Preferences>Transparency & Gamut. You can change the size and color of the checkerboard that indicates the transparent portions of your image. Why? Not sure! Just leave it alone. Actually I did it once just to be different.

Preferences>Units & Rulers. Your default settings in this box will work just fine for most of your work, so just leave this one alone. There is no real reason to change it unless you are working on specific types of images (i.e., web images) or in different measurement systems (such as metric).

Preferences>Guides, Grid & Slices. Here you can change the color and line types of guides and grids. To change them may be important if the guide lines are left as the default blue and you have a blue image. If you need them and can't see them because of the image color, then you can go back here and change them at any time. At the bottom of this box, there is an option to "Show Slice Numbers." If this box is checked, you will see little numbers at the top-left corner of your images. These are annoying if you are not working on web images. To remedy the situation, click on the box and the numbers will go away.

Preferences>Plug-Ins & Scratch Disks. Leave it alone.

Preferences>Image Cache. Leave this one alone for now too.

And that is that! Normally you will not need to go back and change your preferences, but if for any reason you feel you must, you can do so at any time. As you progress in your ability to work in Photoshop, you might find that you can make some changes that better suit the way you work.

5.
IMAGE ADJUSTMENT FEATURES

Now we're getting to the nitty-gritty of Photoshop—neutralizing and controlling color in your images, then adjusting them to suit your needs and your clients' wishes. In this chapter, we will take a look at the various Adjustments tools that are available and what they do.

Under the Image menu you will find the Adjustments option (see fig. 5.1). The various Adjustments tools available will allow you to correct the color and contrast problems in your images. If you are new to making color corrections, it is a good idea to have a color wheel handy to help you to visualize how making a change to one component of your image will affect the others. Visit the Photoshop Help menu and search for "color wheel" then "adjust the color balance" for more information.

The many options outlined below can be used separately or in conjunction with one another (this will depend on each individual image) to achieve accurate results. Remember that when you select a function that is followed by three dots you will have to make some choices. No dots, no choices—just action!

□ LEVELS
The Levels option (Cmd/Ctrl+L) provides several tools that will allow you to make color and contrast adjustments. Each option is outlined below.

IF YOU ARE NEW TO MAKING COLOR CORRECTIONS, IT IS A GOOD IDEA TO HAVE A COLOR WHEEL HANDY....

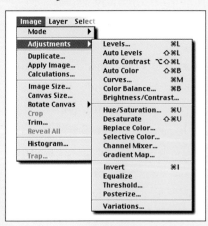

figure 5.1

Histogram. When you select the Levels option, you will see a dialogue box that contains a histogram—an image composed of black lines that represent the color tones in each image. The histogram allows you to see, at a glance, the distribution of tonal levels in your photograph. If the histogram extends the full length of the box, you will know that your image has a full range of blacks, whites, and midtones and is properly exposed.

If the histogram does not extend the full length of the frame, you can use the dynamic sliders located under the histogram (see "Output Sliders," below) to adjust the highlights, shadows, and the midtones in the poorly exposed image. To begin, first slide the black (shadow) slider to the left to the "toe of the mountain" (where the histogram begins), telling Photoshop to make those pixels black. When you slide the highlight slider to the right "toe" (where the histogram ends), Photoshop will make those pixels white. Now that you have white and black, you can adjust the midtones by sliding the middle slider to the right or left, darkening or lightening the image overall. As you move the sliders, you will note that the numbers in the Input Levels boxes change. Manipulating the sliders in this way allows you to easily adjust the brightness and contrast in your image. (*Note:* In most cases, the histogram should slope off at the ends. If you see a tall line at the shadow [black slider] or highlight [white slider] end of the histogram, the image is probably either over- or underexposed. This may not apply to images with an intentional preponderance of dark or light tones, such as high key or low key images.)

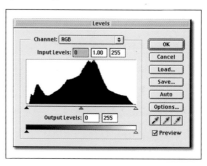

figure 5.2

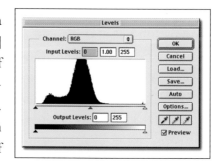

figure 5.3

THE HISTOGRAM ALLOWS YOU TO SEE, AT A GLANCE, THE DISTRIBUTION OF TONAL LEVELS IN YOUR PHOTOGRAPH.

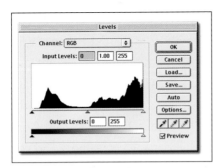

figure 5.4

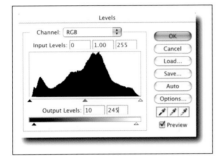

figure 5.5

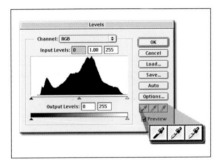

figure 5.6

Let's look at a couple of histograms to determine what they have to say about various images.

The first histogram is from a properly exposed image with details in the highlights and shadows (see fig. 5.2 on page 37). You can see that this image has a full range of tones.

The histogram in figure 5.3 (page 37) indicates that the image is somewhat dark and flat (has no blacks) with most of the pixels darker than midtone gray, and with a few that are nearly white.

In figure 5.4, the histogram indicates that this image has been overexposed; there are a lot of pixels in the highlight range but they are "up against the wall" of the 255 level—white with no detail.

Output Levels. In the Output Levels boxes (below the sliders), set the 0 to 10 and the 255 to 245 as shown in figure 5.5 to control output levels to retain details in the highlight and shadow areas.

Levels Eyedroppers. Notice that there are three eyedroppers located at the bottom right of the Levels dialogue box (see fig. 5.6)—the Set Black Point, Set Gray Point, and Set White Point tools. So what do you do with them? Find a black area (or in the case of a relatively flat image, the darkest part), and select the Set Black Point eyedropper, then click on the darkest part of the image. That will set that point as a true, neutral black and change the remaining colors to the same degree. Next, select the Set White Point eyedropper, and click on the whitest or lightest area of the image (but *do not* click on a specular highlight). Finally, select the Select Gray Point eyedropper, and click on a neutral gray area, or something that should be (these areas are much harder to find than highlights and shadows).

The Click-Balance Method. Before using the "click-balance" method, we must make a couple of changes in the setup. First, make sure that

the Sample Size in your Eyedropper tool Options bar is set at 3x3 Average or 5x5 Average, not Point Sample (see fig. 5.7). Next, with the Levels dialogue box open, double click on the Set White Point eyedropper and the Color Picker dialogue box will appear (see fig. 5.8). Note the RGB values are all 255. This means that when you use the tool, it will make the "R," "G," and "B" values 255, 255, 255. Consequently, at a level of 255, there will be no detail in the whites, and you cannot create them.

Next, enter new values in the "R," "G," and "B" fields. I usually use 245 so that when I make future adjustments, I will not go too far and lose detail. Next, select the Set Black Point eyedropper, and enter a value of 10 in the "R," "G," and "B" fields (see fig. 5.8). These settings will tell Photoshop to set whites to a value of 245 and blacks to a value of 10. You do not have to set the values for the midtone grays because they are already correct. Now make sure that the Preview box is checked also.

While Levels is a powerful tool, it allows adjustments at only three points—the highlights, shadows, and midtones.

☐ AUTO LEVELS

The Auto Levels button (Cmd/Ctrl+L) is found on the right-hand side of the Levels dialogue box. This feature can also be quickly accessed by going to Image>Adjustments>Auto Levels. Using this tool is a no-brainer. It automatically sets the levels by effectively sliding the highlight and shadow sliders in the Levels dialogue box to the "toe of the mountain," whether it is right or wrong. Some say that this option should never be used—and I say don't use it if it doesn't work. Well, okay, try it—it probably won't work, but if it does, you're ahead of the game. Actually, you will get better color than you initially had in the image, but as you become more adept at correcting color, you will understand that there is a better way.

SOME SAY THAT THIS OPTION SHOULD NEVER BE USED— AND I SAY DON'T USE IT IF IT DOESN'T WORK.

figure 5.7

figure 5.8

☐ AUTO CONTRAST

A funny thing happened on the way to version 6.0! For some unknown reason, Adobe added an Auto Contrast adjustment feature.

While certainly not the best way to adjust contrast, it is quick and may do just fine in certain circumstances. The keyboard shortcut is—are you ready?—Opt/Alt+Shift+Cmd/Ctrl+L. Whew—that's too many fingers!

☐ AUTO COLOR

A new feature in 7.0, the Auto Color feature (Shift+Cmd/Ctrl+B) is another "automatic" adjustment. Auto Color seems to do a relatively good job at correcting color in portraits but is not so good with commercial or artistic images. Try it. It won't hurt anything. If it works, great. If not, then move on to some other adjustment tool.

AUTO COLOR SEEMS TO DO A RELATIVELY GOOD JOB AT CORRECTING COLOR IN PORTRAITS....

☐ CURVES

The Curves tool (Cmd/Ctrl+M) is the most powerful adjustment tool in Photoshop because it allows minute (as in small) adjustments in all levels in each image. Figure 5.9 is the dialogue box shown when you first open Curves. To improve the color and contrast in your image, simply set a point on the line by clicking on it and moving it up or down to make the value you selected lighter or darker. (Doing this will also affect adjacent values, but to a lesser degree.) The Curves tool allows you to raise certain values and lower others, creating a complex curve. By moving the highlight portion of the image higher and the darker values lower, you create an "S" curve, adding more contrast (see fig. 5.10). The eyedroppers in this dialogue box work the same way as in the Levels dialogue box.

Note: You can also adjust the color balance of individual color channels by using either the Levels or Curves function (see fig. 5.11). You

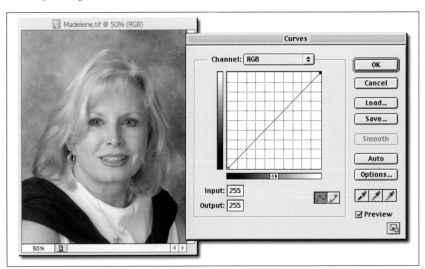

figure 5.9

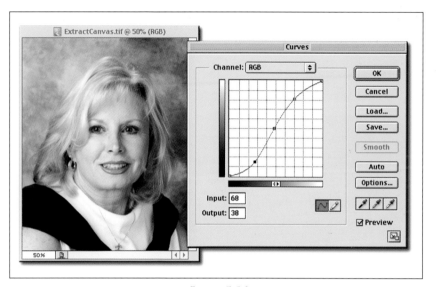

figure 5.10

can adjust the reds and cyans in the Red channel; the blues and yellows in the Blue channel; and the greens and magentas in the Green channel. You can save the adjustments when you are through and recall the settings in another image by telling Photoshop to "load" the saved adjustment. To recall the last adjustment, you can use a keyboard shortcut. Just add the Opt/Alt key to the standard shortcut to access the adjustment feature. Opt/Alt+Cmd/Ctrl+M will apply the last Curves adjustment. Opt/Alt+Cmd/Ctrl+L will apply the last Levels adjustment (and so on . . .). The Levels or Curves dialogue box will appear, but this time with the same adjustment made the last time. You can either say OK or make additional adjustments as needed. *Note:* This Adjustments shortcut works with the other color and contrast adjustments as well; to recall the adjustment setting applied in your previous use of the feature, simply add the Opt/Alt key to the keystroke grouping.

Note: If this is the first time you have used the Curves adjustment dialogue box, you'll want to make two changes to the default settings in

<div style="float:left">

THE CURVES TOOL ALLOWS YOU TO RAISE CERTAIN VALUES AND LOWER OTHERS, CREATING A COMPLEX CURVE.

</div>

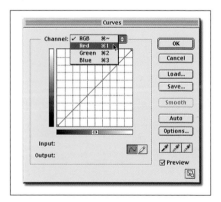

figure 5.11

figure 5.12

this dialogue box (which suit graphic designers, but not photographers). (See figure 5.12 on page 41.)

1. Hold down the Opt/Alt key and click inside the graph box. It will change from the four-zone to the ten-zone option, which is similar to the ten levels of Ansel Adams's Zone System and is more familiar to photographers.

2. If your highlight/shadow is set up like it is in the background box in figure 5.12, note that the gradient at the bottom (right below the graph) has a black and a white arrow. Click on the little arrows, and you will see the gradient reverse itself. This option means that as you raise a point on the line, it will lighten the tones in your image, and as you pull it downward, it will make the tones darker. This is much more intuitive for the photographer. The default setup is based on ink usage and is the opposite of how photographers need to adjust an image.

☐ COLOR BALANCE

The Color Balance (Cmd/Ctrl+B) dialogue box (see figure 5.13) allows you to add or subtract any of the six colors—red, green, blue, cyan, magenta, or yellow—to/from the shadows, highlights, or midtones, but it does not allow you to change the lightness or darkness of an image. Using the Color Balance option without a selection produces global changes to an image; with a selection, only the selected area is affected. And, as in Levels and Curves, Opt/Alt+Cmd/Ctrl+B will give you the last Color Balance as a starting point on a new image. If you have trouble remembering which colors are complementary, this dialogue box will give you a visual! Remember that as you add any color, you subtract its complement!

USING THE COLOR BALANCE OPTION WITHOUT A SELECTION PRODUCES GLOBAL CHANGES TO AN IMAGE.

☐ BRIGHTNESS/CONTRAST

Brightness/Contrast is just that—a way to change the brightness and contrast of an image. For many, the most important option in this dia-

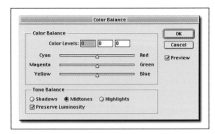

figure 5.13

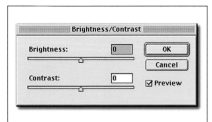

figure 5.14

logue box (see fig. 5.14) is acknowledged to be the Cancel option. Adding contrast lightens the whites and darkens the shadows, affecting only the two ends of the tonal scale. Levels affects at least three points, and Curves can correct 256, so you figure out which one is best. Brightness adds or subtracts brightness through the manipulation of two sliders. While you can accomplish the same result with much more control elsewhere, Brightness/Contrast offers quick corrections when you don't have any time—but don't tell anyone that I told you to do it! And there is no keyboard shortcut for this function, which is just fine.

☐ HUE/SATURATION

The Hue/Saturation (Cmd/Ctrl+U) dialogue box allows you to control the hue, saturation, and lightness of the overall or individual colors in an image. Adjusting the Hue is like shifting the overall color around the color wheel. Adjusting the Saturation adjusts the actual purity of a color—the more saturated it is, the more it approaches the pure color

HUE/ SATURATION IS VERY POWERFUL BUT LIMITED IN ITS USEFULNESS TO PORTRAIT PHOTOGRAPHERS.

and the darker it usually becomes. Lighten is pretty simple to understand when you use it. Hue/ Saturation is very powerful but limited in its usefulness to portrait photographers.

Colorize. This cool feature allows you to add color to a grayscale image after it has been converted to RGB mode. It can also be used to colorize an RGB image. To do so, simply click the Colorize option in the Hue/Saturation dialogue box, then slide the Hue slider to create an overall color cast (see figure 5.15). This feature adds an overall color (hue) to the image, but it does not make a black & white into a color photograph with natural colors. Try this: Take an RGB image, go to Image>Adjustments>Hue/Saturation. Next, check Colorize and slide the Hue slider to somewhere in the 33–38 range. With this accomplished, move the Saturation slider up or down a little to suit yourself. Look like a sepia tone? Cool, huh?

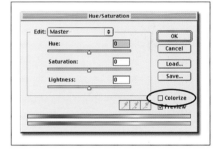

figure 5.15

☐ DESATURATE

This is easy: Desaturate (Shift+Cmd/Ctrl+U) desaturates the image! Okay, it takes out *all* the color and leaves you with an RGB version of a black & white image. When you use this feature, you will not see a dialogue box and will not be able to make any choices—the effect will simply happen. *Note:* This is *not* the best way to convert to black &

white but will take out 99 percent of the color and allow you to do some interesting tinting and special color effects.

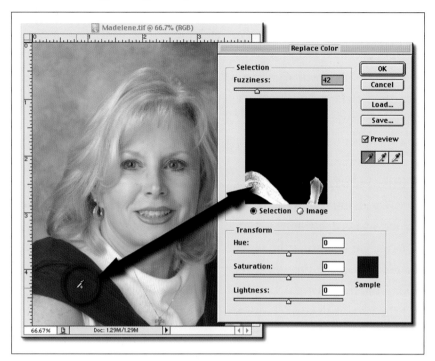

figure 5.16

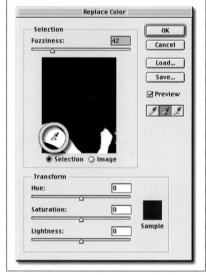

figure 5.17

☐ REPLACE COLOR

The Replace Color function is a seldom used but powerful tool. It is used to replace the color of an object in an image. In the dialogue box, make sure the Selection option is checked (immediately under the image box), slide the Fuzziness dynamic slider to about 40, then move the cursor inside the image box and click on the color you want to replace. In fig-ure 5.16 the sweater was selected by clicking the eyedropper on a point in the subject's sweater. As in any "mask" selection, the old adage "white reveals, black conceals" applies in this image, so in the image box, the "selected" portion of this image is white. You can select more of the color you want to replace by selecting the eyedropper with the "+" and clicking on either the image or the selection box inside the dialogue box (see fig. 5.17). As you move the Fuzziness slider, you will see that more or less of the image is

AS YOU MOVE THE FUZZINESS SLIDER, YOU WILL SEE THAT MORE OR LESS OF THE IMAGE IS "SELECTED"....

"selected" for the color replacement (see fig. 5.18). Once you have made the selection you want, adjust the Hue, Saturation, and Lightness sliders until you have the desired color (see fig. 5.19). The one thing you need to know is that when you make a selection using the Fuzziness option, it selects *all* the similar colors in the image. Note that for this image, the fuzziness setting was set *lower* than the original. If you want to apply the effect only selectively, select the object or area you want to alter prior to using the Replace Color function.

◻ SELECTIVE COLOR

As the name suggests, this feature allows you to make changes to a single color in your image. In figure 5.20 (page 46), you will note that the default selected color is red, but you can use the pull-down menu to make changes to any of the nine color choices. Once you select the color you want to change, use the dynamic sliders to add or subtract cyan, magenta, yellow, or black from your chosen color. When making adjustments, remember the complementary colors: to add red, subtract cyan; to add green, subtract magenta; to add blue, subtract yellow, and white, subtract

AS THE NAME SUGGESTS, THIS FEATURE ALLOWS YOU TO MAKE CHANGES TO A SINGLE COLOR IN YOUR IMAGE.

figure 5.18

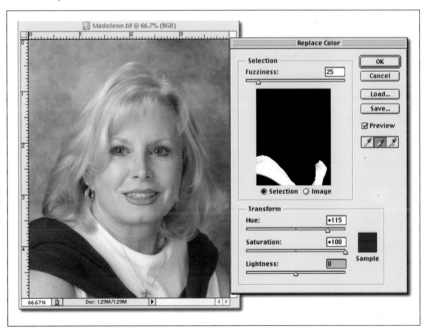

figure 5.19

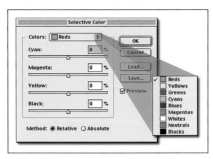

figure 5.20

black. *Warning:* If you add more black to darken a color, you also add unwanted noise. So be very careful when adding black!

The choice of Absolute or Relative will add more or less color when using this feature. Selecting Absolute will add a certain amount of color based on your positioning of the dynamic slider. Choosing Relative will add a color amount based on your positioning of the slider but will add more or less color based on the relative amount of that color in the image. Choose Absolute for faster application.

☐ CHANNEL MIXER

By "mixing channels," you can combine color channels to produce a unique effect and can therefore make color adjustments that are impossible with other color correction tools. This function also allows you to create tinted images or even swap or duplicate channels. Most of these uses are for creative image making. As a photographer, the best use of the Channel Mixer is the creation of high-quality grayscale images.

After choosing Channel Mixer, you can select any of the Output Channel options at the top, add or subtract any of the colors, and change the contents in the Output Channel you selected to change the overall color (which isn't overly useful for everyday image corrections). However, if you check the Monochrome option at the bottom of the dialogue box, the image becomes black & white and you can then "mix" the various channel to control tonal variations. *Note:* There is some math involved as you change the values. They need to add up to 100 percent, so get out your calculator! But there are no rules that require all positive (plus) numbers. You can have a minus green (–50) and plus blue (+100), and red (+50); there are no limits except to your imagination and patience.

BY "MIXING CHANNELS," YOU CAN COMBINE COLOR CHANNELS TO PRODUCE A UNIQUE EFFECT....

☐ GRADIENT MAP

Another "creative" use of color, the Gradient Map option replaces the tonal variations in an image with the colors of a specific gradient fill. This technique is not applicable to portrait/wedding photography.

☐ INVERT

This function "inverts" the image, creating a "negative" version of the original image, for whatever that is worth. This function is not particularly applicable to general portrait/wedding photography!

☐ EQUALIZE

The Equalize command redistributes the brightness values of the pixels in an image so that they more evenly represent the entire range of brightness levels. When you apply this command, Photoshop finds the brightest and darkest values in the composite image and remaps them so that the brightest value represents white and the darkest value represents black. Photoshop then attempts to equalize the brightness—that is, to distribute the intermediate pixel values evenly throughout the grayscale.

You might use the Equalize command when a scanned image appears darker than the original and you want to balance the values to produce a lighter image. Using Equalize together with the Histogram command lets you see before-and-after brightness comparisons. This function is very similar to the Auto Levels command.

☐ THRESHOLD

The Threshold function is used to convert images to high-contrast black & white images. By dragging the slider in the dialogue box (see fig. 5.21), you select a "threshold." All the pixels that are lighter than the threshold point are converted to white and those that are darker are converted to black. One of the most common uses of this Adjustment option is to find the darkest and lightest part of an image so that you can use the shadow and highlight eyedroppers in either the Curves or Levels adjustment options to correct color.

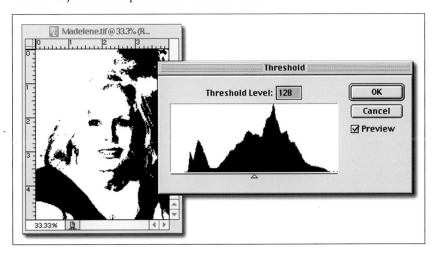

figure 5.21

◻ POSTERIZE

Posterize is used to create special color effects in an image. This tool allows you to restrict the number of tones that appear in your image—a function that you may never use in a portrait.

◻ VARIATIONS

Last in the Adjustments menu, but certainly not least, the Variations options allow you to see thumbnails of your image, providing a visual record of how an image will look when color and density corrections are made. In figure 5.22, you will see the various options. Note that you can increase or decrease the amount of correction by moving the slider to Fine or Coarse, and you can select the areas of the image where the corrections are made, be it the highlights, midtones, or shadows. You can also select the Saturation option to adjust the overall color satura-

NOTE THAT YOU CAN INCREASE OR DECREASE THE AMOUNT OF CORRECTION BY MOVING THE SLIDER TO FINE OR COARSE....

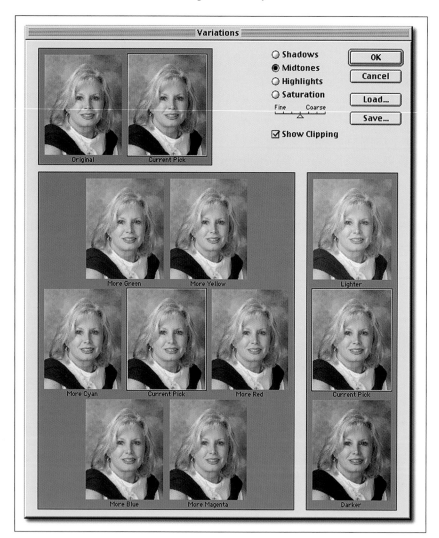

figure 5.22

tion of an image. If you check the Show Clipping option, there will be "neon" indication (a noise-like pattern) in areas in the image that will be "clipped" (converted to pure white or black), which may result in undesirable color shifts. Note that this does not occur when you make an adjustment to the midtones. The Variations feature is most useful on medium-key images and does not work on indexed color images.

6.
USING THE
ADJUSTMENT FEATURES

Today's scanners and digital cameras produce better color images than ever before (there is less color bias or color cast in images produced by the newer devices), and things will likely continue to improve. While this is a clear benefit for photographers, it is not the only one: Many photo labs are returning to the "old way" of doing business—actually doing color and tonal corrections themselves. But the bottom line is that color correction is still a requirement if you are outputting images at your studio.

Color monitors have always been a source of incorrect color, and that's not likely to change. The problem lies not so much in our studio monitors, but those that belong to our clients. As professionals, we have two options for ensuring proper calibration: (1) We can use high-end monitors and keep them correctly calibrated using calibration software that comes with the monitor, or (2) We can purchase the hardware/software available from professional suppliers.

THERE IS A WAY TO REMOVE OVERALL COLOR CASTS— WITHOUT EVEN SEEING THEM ON A CALIBRATED MONITOR.

While these options are certainly effective, there is a way to remove overall color casts—without even seeing them on a calibrated monitor.

☐ THE 90 PERCENT METHOD OF COLOR CORRECTION
Of all the methods of basic color correction, the 90 percent method is most often used to provide relatively accurate initial color correction. Why "90 percent?" Because it works about 90 percent of the time— which is not 100 percent, but makes for pretty good odds. *Note:* While this method may at first seem complicated, you will become more efficient at using it with practice.

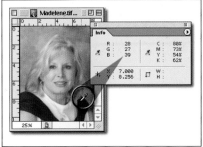

figure 6.1

figure 6.2

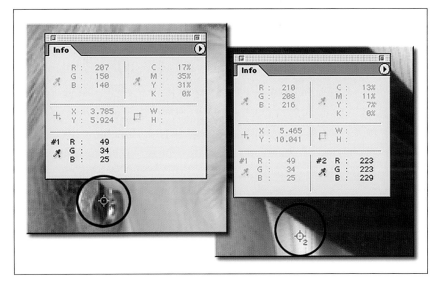

figure 6.3

COLOR NOTATIONS

In the chapters that follow, colors will be noted as follows: 60R/50G/10B. This example denotes a color where Red is set to 60, Green is set to 50, and Blue is set to 10.

With your image open, make sure that the info palette is also visible (if not, just go to Window>Info). Next, select the Color Sampler tool (see fig. 6.1), which is located in the same window as the Eyedropper tool (the tool's icon is an eyedropper plus a little target). In the Options bar, be sure to set the Sample Size to 3x3 Average.

THE INFO PALETTE PROVIDES YOU WITH THE "RECIPE" FOR THE COLOR VALUES IN YOUR IMAGE....

The info palette provides you with the "recipe" for the color values in your image (i.e., 13R/14G/18B). The lower the values are, the darker the color; the closer the RGB values are to each other, the more neutral the color. This is a premise you need to remember. In figure 6.2, the Red and Green values are close and the numbers are low. The Blue value is higher, but still relatively low. What does this mean? That the point at which this image was sampled, the color should be a dark blue. Guess what? It is!

Next, look for the "black" point in the image (see fig. 6.3). This does *not* actually have to be black, but it needs to be a very dark neutral gray. Why is this? Well, your job is to correct the color—to neutralize it, making whites white and blacks black. But in doing so it also makes grays a neutral gray—without color bias. So if you do not have a true black, you can more than likely find a lighter area that needs to be neutral. Nope, it doesn't *always* work because your image may not have any blacks or grays, but that is why this is the 90 percent method and not the 100 percent method of color correction. When you find the right area to sample, click the mouse and you will see a little mark left at that sampled point. (*Hint:* This point is set using the end of the eyedropper, not the little target.) In this case, the values for the dark point are: 49R/34G/25B. While true "black" is around a 6 level, this area in my image should at least be a neutral "dark" area.

Now move the Color Sampler tool to where you think the lightest neutral spot is on the image and click the mouse. Voilà, another target! I selected my sample point from the sweater—a known white—and my numbers were 223R/223G/229B (see fig. 6.3). Now note the info palette; you will see that it has expanded, and the values for the two colors you selected are noted on the palette; these are labeled #1 and #2 (see fig. 6.3 on page 51).

With the info palette still visible, go to Image>Adjustments>Levels (Cmd/Ctrl+ L). In this palette, you will now see two sets of RGB values, separated by a slash, for your #1 and #2 values. These are the "before and after" numbers. You will use the numbers shown after

WHEN YOU FIND THE RIGHT AREA TO SAMPLE, CLICK THE MOUSE AND YOU WILL SEE A LITTLE MARK LEFT AT THAT SAMPLED POINT.

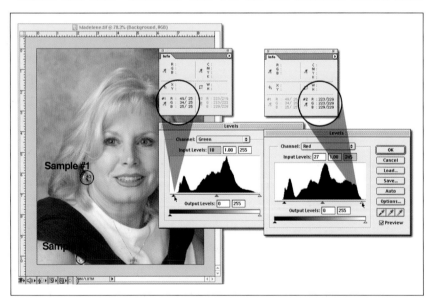

figure 6.4

the slash to adjust your colors (see fig. 6.4). (The "after" numbers—the ones after the slash—will change as you make your adjustments.)

Now, let's make our color corrections using the 90 percent method. To begin, look at the numbers in window #1 in the info palette (from the first dark color sampler pick) and find the channel with the lowest number. This indicates the darkest level. In our sample it is the Blue channel (25). This will be our "low point"—the one that we want the rest of the channels to match (or at least closely match). Since the Blue channel is the lowest, select the Red channel in the Levels dialogue box (see fig. 6.4) and click and hold on the Shadow (black) slider, found directly below the histogram. You are going to move the slider to the right and watch the numbers in the info palette at the same time. Move the Red channel shadow slider until the number in the info palette after the slash is 25, so that both the Red and the Blue channels have the same value.

Now select the Green channel and do the same thing you did with the Red channel shadow slider. Move it until the number after the slash in the info palette reads 25 (or close). You have now adjusted the "shadows," making them neutral.

Now, let's make the same adjustments using the Highlight slider. Since the Blue channel also happens to be the highest number in window #2 of the info palette, we will adjust the Red and Green channels to match this value. Select the Red channel again, then move the Highlight slider (see fig. 6.4) to the left until the number in the info palette matches the Blue channel number (229 in my image). Do the same with the Green channel.

You may notice that the numbers that you set in the shadow adjustment initially might have changed slightly. This is normal. If they have not changed too much, you can leave them alone, or you can readjust the shadows until they match again. You may also then need to readjust the highlights again, and then . . . well, get the picture? Close, within five points, is good enough here unless you have nothing else to do except spend your time messing with dynamic sliders.

Final Corrections. At this point, you have neutralized your image, but you still may not be satisfied with the overall appearance of the image on your screen. It may seem a little dark or a little light, the contrast may be off, it may have a slight color bias, whatever. To complete this task, go to Image>Adjustments>Curves (Cmd/Ctrl+M) and make the final contrast and density adjustments to suit yourself. You can then use the Color Balance feature (Image>Adjustments>Color Balance [Cmd/Ctrl+B]) to modify the overall color balance to suit your person-

al taste. Go back to chapter 5 if you need to refresh your memory on these features.

☐ ADDITIONAL COLOR BALANCING METHODS

While the 90 percent method is your best choice, there are images that do not lend themselves to that method. The following two methods are much quicker though considerably less reliable.

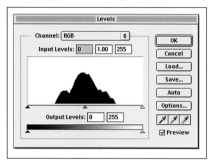

figure 6.5

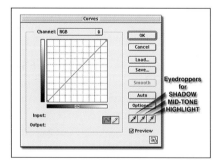

figure 6.6

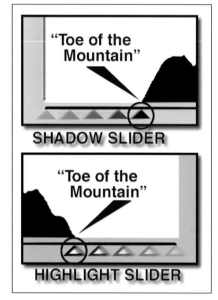

figure 6.7

Going to the Mountain. Employing another technique, mentioned in chapter 5, will allow you to achieve better contrast in your images. With your image open, open the Levels dialogue box (Cmd/Ctrl+L) and look at the histogram (see fig. 6.5). Note that in this case, it does not extend to either end of the scale, meaning that there are no real blacks or pure whites in this image. Using this method, we will tell Photoshop to make the darkest pixels black and the lightest pixels white. Make sure that the channel selected is the composite RGB, not an individual color channel, then:

1. Click on the black (shadow) slider and move it to the right until it touches the point where the histogram meets the bottom line. This will adjust the darkest pixels to black (see fig. 6.6).
2. Next, click on the white (highlights) slider and move it to the left until it touches the point where the histogram meets the bottom line. This will adjust the lightest pixels to white (see fig. 6.6).

WHILE THE 90 PERCENT METHOD IS YOUR BEST CHOICE, THERE ARE IMAGES THAT DO NOT LEND THEMSELVES TO THAT METHOD.

3. Click on the midtone slider (the gray one in the middle) and move it to the right or left to adjust the overall tone of the image as necessary.

At this point, you may want to make some additional color balance and contrast corrections using the Color Balance and Curves adjustments. While this is certainly not the preferred method, it will work well enough when there is no other obvious option.

Click and Easy. This is the quickest and easiest of the color adjustment methods, but it is certainly not the most accurate. It requires that you find a true black and a true white in your image—or settle for something close. The 90 percent method outlined above allows much more flexibility in selecting neutral colors versus true blacks and whites.

To make our corrections using this method, we are going to use the Eyedropper tool found in either the Levels or Curves dialogue box (see fig. 6.7). If you have followed along with the techniques we've covered, you have already set the values for your Highlight and Shadow eyedroppers and the sample size for your Eyedropper tool. (If not, go back to the section on Levels in chapter 5 and work through that exercise. Once done, your settings will become the default numbers and you will not have to do them again.)

Once these settings have been made, with your image open, you can open either the Curves (Cmd/Ctrl+M) or Levels (Cmd/Ctrl+L). (Personally, I use the Curves adjustment function.) To use this color adjustment option, select the Set Black Point eyedropper (the black one on the left) and click on a point in your image that "should be" black. Next select the Set White Point eyedropper and click on a point in your image that should be white. If there is something in the image that you know is a midtone gray, then you can also use the Set Gray Point eyedropper (midtones) and click on a midtone gray to make a final adjustment. With each click, you will note a change in color and tonality in your image. That is what is supposed to happen. Is it correct? That depends primarily on where you click—if you've made the correct selection, you'll find that you're in good shape; if you've made a poor one, you will know it immediately! *Note:* It is important that you select only true white or black and not another color—or even a gray area—to click on when using the highlight and shadow eyedroppers!

Once again, you may have to go back and make further adjustments using Curves (which is why I use the Curves function to begin with). On the other hand, you can also make adjustments with the Color Balance function until you have your image looking the way you want it to.

The Click-Balance Method. This color neutralization method can be planned in advance for *every* portrait. There are no rules, only results—and the end justifies the means.

The click-balance method not only works in theory but is also effective in practice with only a little bit of thought. The first thing you need to do is make a "target," a known black, white, and neutral swatch in the image that you can use in color balancing the entire image. While these materials

figure 6.8

can be readily purchased, there are some very inexpensive and creative alternatives.

To create a gray target, purchase a Kodak 18 percent gray card. They are relatively inexpensive and very durable if you get the 8.5x11-inch plastic version. You also need two other items: A white square and a black square. I suggest cutting a piece of brilliant white matte inkjet paper approximately 4x4 inches square for the white, and using either black velvet or felt (something that does not reflect much light) for the black square. Cut it to the same size as the white paper target. Now glue these squares to the gray card. I simply have my subjects hold it for the first shot, use it to make my corrections, and then apply those same corrections to each of the final images (see fig. 6.8).

Again, with these swatches in your image, you have a *known* white, black, and neutral midtone gray—ideal for click-balancing to neutralize your images using the above technique. So what "secrets" do you need to know? Only one: Make sure you are not getting specular highlights (reflections of the light source) off the card. It will blow out the white and even make the black too bright, forcing Photoshop to make poor color corrections. Tilt the card down so it does not reflect any light sources, just like photographing a certificate presentation. Problem solved!

WITH THESE SWATCHES IN YOUR IMAGE, YOU HAVE A KNOWN WHITE, BLACK, AND NEUTRAL MIDTONE GRAY....

7.
BASIC RETOUCHING TECHNIQUES

Now that you have neutralized and color corrected your image, the next step in your workflow is to perform basic retouching. In this chapter, you will learn how to eliminate blemishes, brighten the eyes, whiten the teeth, eliminate straggling hair, and fix other minor problems. The techniques covered in this chapter are performed on almost all portrait images. In chapter 8, we will cover some more advanced techniques that will solve some less common problems.

☐ RETOUCHING TOOLS

Until Photoshop 7.0, the Clone Stamp tool (formerly called the Rubber Stamp tool) was used in the vast majority of retouching jobs. Photoshop 7.0 introduced two new tools for the photographer that are useful for retouching: the Healing Brush and the Patch tool. All of these tools function in what is basically a "copy and paste" mode. Using the tool, you first select the area (the pattern of pixels) that you want Photoshop to remember, then you decide where to put it.

figure 7.1

Clone Stamp Tool. The Clone Stamp tool icon (Keyboard shortcut: "S") looks like a rubber stamp (see fig. 7.1) and is the fifth tool down on the left-hand side of the tool palette. Even though each of the three retouching tools have various Mode options, the Clone Stamp tool is unique in that it allows you to select an Opacity

THE TECHNIQUES COVERED IN THIS CHAPTER ARE PERFORMED ON ALMOST ALL PORTRAIT IMAGES.

figure 7.2

setting, and therefore provides the most streamlined, refined, and realistic corrections.

Warning: There are two tools contained in this location on the tool palette. The second, the Pattern Stamp tool (see fig. 7.2),

figure 7.3

figure 7.4

uses the pattern palette as the "source" for its information. If you inadvertently select this option, it will quickly become obvious; instead of replacing blemishes with good skin, a stamped pattern will appear. To correct this mistake, delete the Pattern Stamp history states, select the Clone Stamp tool, and get back to work!

Looking at the tool options in the Options bar at the top of your screen (see fig. 7.3), you will see that you can select different tool Presets, Brushes, and Modes—and a new option called Flow. You can also select the Aligned and Use All Layers options. Before entering anything in these fields, however, let's take a look at what these options do.

Tool Presets. The tool presets icon is not labeled as such (see fig. 7.4), but this is the area where you may eventually store any "presets" that you will use for different types of retouching. It is the first box on the left side of the Options bar. You will see a depiction of the tool icon for the tool that you have selected. If you generally use certain tool–option combinations when retouching, you can set a tool preset—a veritable shortcut for selecting your preferred settings. When you are ready to use the stored technique, you click on the tool preset, select the preset you want, and go to work. Using this feature becomes a real time-saver once you get the hang of saving your preferences.

Brush. The next box over is labeled Brush (see fig. 7.5); this is where you select the type and size of brush you want to use. You can also select the brushes palette (see fig. 7.6) from the Image Well and you will get

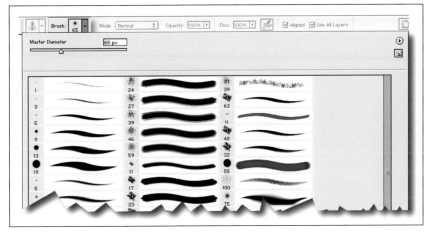

figure 7.5

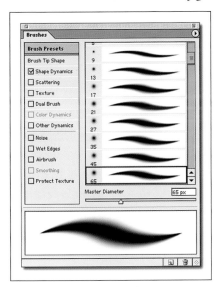

figure 7.6

a different view of the brushes—
and some more choices. For the
most part, you will use a round,
soft-edged brush. *Hint:* There is a
quick and easy way to change
brush sizes and even the hardness
of the brush. When you have
selected any particular round
brush, you can change the size by
using the bracket keys—([) and

figure 7.7

(])—found immediately to the right of the "P" key. The left bracket ([)
will make the brush smaller and the right bracket (]) will make it larg-
er, and pressing the Shift key while you hit the bracket keys will make
the brushes softer or harder. Watch the Brush tool icon in the Brush
window and you will see exactly what is happening.

figure 7.8 figure 7.9

Mode. The Mode option will change how Photoshop "blends" the Clone Stamp as you use it (see fig. 7.7 on page 59). The various modes dictate how the effects will be applied. The ones you will use the most are Normal, Lighten, and Darken. Set in Normal Mode, the cloning effect will be applied exactly as it was copied (same color, same tone). Using the Lighten Mode, only the darker pixels will be affected—and they will be replaced. The Darken Mode is exactly the opposite, making only the lighter pixels darker. The Lighten and Darken Modes are most effective in eliminating dust spots and noise.

Opacity. The next box in the Options bar is labeled Opacity (see fig. 7.8). Just that, the opacity setting defines how much retouching is actually applied, giving you a great deal of control over the retouching process. A 100 percent setting means that *all* of the sample will be used, while settings of 60 percent, 30 percent, etc., mean that only that specific amount of the sample will be applied. (*Note:* A shortcut to changing the Opacity is to simply type a number using your number keys. To set the opacity at 50 percent, type 5. For 20 percent opacity, type 2; for 100 percent, press 0.)

Flow. The Flow setting is used only when the Airbrush option is selected in either the Clone Stamp tool or Brush tool. It is like changing the hole size in a spray can, allowing more or less paint to flow onto the image. Using a low setting and holding down the mouse button will slowly apply more clone or paint effect. It is like setting the the Opacity low and clicking multiple times but easier.

Airbrush. Prior to Photoshop 7.0, the Airbrush tool was found in the tool palette; however, it is now an option for both the Clone Stamp tool and Brush tool in the Options palette found at the top of the screen. To use the Airbrush, first select either the Brush tool or the Clone Stamp tool. Next, click on the Airbrush option at the top of the screen, then set the tool's Flow rate (see fig. 7.9). There is a small but significant difference between the performance of the Airbrush and the Brush tools. Each selection has its own unique applications: When you use the Airbrush tool, color will "puddle" as you continue to press on your mouse; when you use the Brush option, the color will be applied evenly—in other words, you can hold your mouse button as long as you like,

THE FLOW SETTING IS USED ONLY WHEN THE AIRBRUSH OPTION IS SELECTED IN EITHER THE CLONE STAMP TOOL OR BRUSH TOOL.

and the amount of color you apply to a particular area will remain constant, producing even color. Keep in mind that the Clone Stamp—at its default setting—will apply color like the Brush tool. If you prefer, you can select the Airbrush tool as outlined above.

Aligned. This is a very important option that controls the way in which pixels are sampled and placed on your image. When the Aligned option is selected (see fig. 7.10), Photoshop will maintain the sample point at a consistent angle and distance based on the first Opt/Alt click of the the mouse. As you move the "destination" of the tool, the "source" point will follow it around as you click (see fig. 7.11). The "source" is indicated by a small cross, and the "destination" is your brush (see fig. 7.12). You actually select a new sample point each time you click the mouse. By deactivating this option, you will use the original sample point each time you click unless you "paint" with the brush; in that case, the sample point will follow the brush.

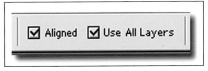

figure 7.10

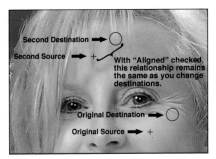

figure 7.11

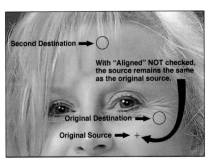

figure 7.12

figure 7.13

figure 7.14

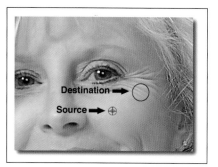

figure 7.15

Use All Layers. This is a time-saving feature that allows you to sample data from any of your visible layers—and even permits the application of the sample to a transparent layer.

The Clone Stamp is best applied by a series of mouse clicks, *not* with a painting motion. In the words of retouching guru Jane Conner-Ziser, you should "poof," with this tool, not paint with it, as using a painting motion with this tool will often create repeating patterns. You will learn to use the Clone Stamp well in the same way you get to Carnegie Hall— practice, practice, practice!

Hint: You can work on a digital image at any level of magnification. Do your retouching at at least 100 percent, and don't be afraid to go to 200 percent or 400 percent (see fig. 7.13). You can even work on one pixel at a time if you enlarge the image enough—but that may become very time-consuming. But *always*, and I mean *always*, view the results at 100 percent. A shortcut to this level of enlargement is Opt/Alt+Cmd/Ctrl+0 (zero, not "oh"). This is important because 100 percent actually means a 1:1 pixel ratio on the screen, as one pixel on the screen represents one pixel in the image.

Healing Brush Tool. The Healing Brush tool is new to Photoshop 7.0. To use it, select the bandage icon in the tool palette (see fig. 7.14). It is very similar to the Clone Stamp tool in that you select an area you want to "copy" and then "paste" it onto an area you want to repair. The primary differences are: (1) It automatically calculates the changes in color and tonality between the "good" area and the "bad" area and corrects the information you are moving, and (2) There is *no* option to control the opacity of the brush, so you get the full effect of each application.

So how do we use this tool? You select the tool (keyboard shortcut: "J") and, for most applications, set the mode to "Normal." Remember the Mode options here work the same as in the Clone Stamp tool, so you may want to use Lighten or Darken depending on the image. Select either the Sampled or Pattern option to indicate the type of sample you

YOU CAN EVEN WORK ON ONE PIXEL AT A TIME IF YOU ENLARGE THE IMAGE ENOUGH—BUT THAT MAY BE VERY TIME-CONSUMING.

wish to use in the image. If you choose Sampled, this tool will work like the Clone Stamp; if you choose Pattern, you will need to select a pattern, and the tool will work like the Pattern Stamp.

Here is where we apply the control factor for this tool. Make a copy of the background by dragging the layer icon onto the New Layer icon at the bottom of the layers palette (or use the shortcut Cmd/Ctrl+J) before you start (which is always a good idea!). This will be your control layer when you are through retouching. You will use this layer to control the amount of retouching you apply by lowering the opacity setting for this layer when you have completed the work.

Choose Sampled, find an area of good skin and Opt/Alt click, then move your brush to the areas you wish to repair, and go to work (see fig. 7.15). (Remember, checking Aligned in the Options bar will keep the distance and angle of the source/destination the same, exactly as it did with the Clone Stamp tool. If you do not check Aligned, only your initial selection will be applied, no matter where you move the tool.) You must "poof" with this tool like the Clone Stamp. Regardless of the selection or nonselection of the Aligned option, do not paint with this tool. The source will follow the destination (stay aligned with it regardless of the setting) and will cause some problems. You will note that regardless of where you selected your "source" information, it will be corrected to match the "destination" area. If you do paint, and you can if you're careful, you will note that there is a slight delay as the correction adjusts itself to match the area onto which the sampled area was painted (see fig. 7.16).

IF YOU DO NOT CHECK ALIGNED, ONLY YOUR INITIAL SELECTION WILL BE APPLIED, NO MATTER WHERE YOU MOVE THE TOOL.

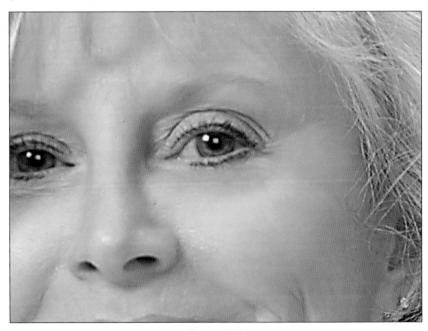

figure 7.16

You will also note that the retouching is usually "too much," meaning the retouched area is too smooth and unnatural. So once you have completed your retouching, grab the Opacity slider in your layers palette and move it to the left to lower the opacity until you bring back some of the texture of the original skin. I use 50 percent opacity more often than not (see fig. 7.17).

I would suggest saving the image as a PSD file so you can retain the additional retouched layer. If you give the image to a client, then flatten it, save it as a TIFF file, and put it on CD. Done deal!

Patch Tool. This is the second new retouching tool in Photoshop 7.0, and it is found in the same place as the Healing Brush tool (see fig. 7.18). The Patch tool works very much like the Clone Stamp or Healing Brush tool but is much quicker. However, your options are somewhat more limited in that you can choose only Source or Destination (and you will most likely want to keep it on Source).

THE RETOUCHING IS USUALLY "TOO MUCH," MEANING THE RETOUCHED AREA IS TOO SMOOTH AND UNNATURAL.

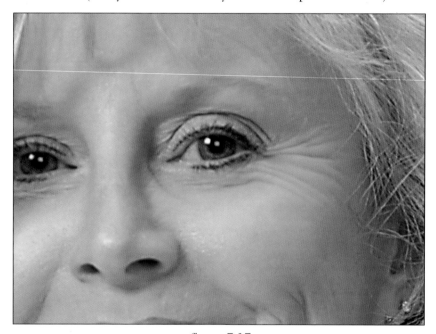

figure 7.17

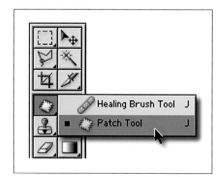

figure 7.18

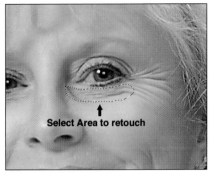

figure 7.19

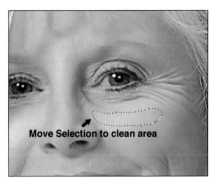

figure 7.20

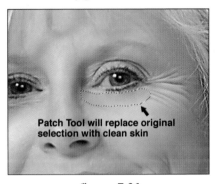

figure 7.21

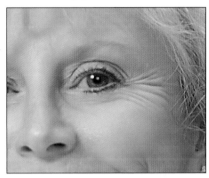

figure 7.22

WITH A FEW SIMPLE TECHNIQUES, WE CAN BRIGHTEN THE EYES, GET THE RED OUT, AND ADD SOME SPARKLE.

You will note that this tool's icon looks like a "squiggly" Lasso tool—and it is! To use the Patch tool, you "lasso" the area you want to repair (see fig. 7.19), and then put your cursor inside the selected area. You will now note that when the cursor is inside the selection (indicated by "marching ants"—a dotted black line that surrounds the area), you can click, hold, and drag the selection to "clean skin" area and then let go (see fig. 7.20). The Patch tool will correct for color and tonality and drop the selected area back at the place you originally picked to repair (see fig. 7.21).

As with the Healing Brush tool, you cannot control the opacity for the Patch tool, so you must first make a copy of the background image, apply the retouching to that layer, and then lower the opacity to bring back some of the texture contained in the original photograph (see fig. 7.22).

☐ BRIGHTENING THE EYES AND ADDING SPARKLE

We have all had clients who had dark irises or bloodshot eyes; fortunately these problems are a thing of the past in the digital portrait. With a few simple techniques, we can brighten the eyes, get the red out, and add some sparkle.

First zoom in tight—to 100 percent at least, and don't be afraid of 200–300 percent (see fig. 7.23 on page 66). Note that often there are two highlights in each eye (called catchlights), and they are sometimes

very distracting. Let's get rid of the unwanted highlight and enhance the primary one:

1. First, get the Clone Stamp tool and set the Mode to Darken.
2. Make your brush size small and soft so you can work close.
3. Select a good dark area of the pupil and clean up the second highlight (see fig. 7.24).
4. Get the Dodge tool (see fig. 7.25) and set the Opacity at about 40–50 percent.
5. Center the Dodge tool over the existing primary highlight (made by the main light) and click until you have lightened that highlight to your satisfaction (see fig. 7.26).
6. Change the Opacity setting of the Dodge tool to about 30 percent, and make a small semicircular pass over the colored pupil area directly opposite the primary highlight (see fig. 7.27). This looks very natural and adds depth to the eye.

FIRST, GET THE CLONE STAMP TOOL AND SET THE MODE TO DARKEN. THEN MAKE YOUR BRUSH SIZE SMALL AND SOFT....

figure 7.23

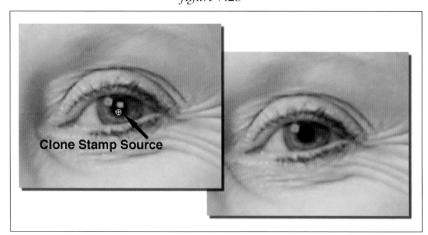

figure 7.24

figure 7.25

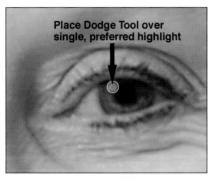

figure 7.26

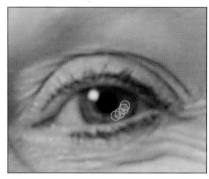

figure 7.27

7. If the whites of the eyes are bloodshot, you have two choices:

a) Use the Dodge tool at an Opacity setting of 20–30 percent, and set the Range to Highlights. Carefully dodge out the white areas to lessen the redness. Using a low Opacity setting takes longer but gives you more control.

b) Carefully select the whites of the eyes using the Lasso tool with a 1 to 2 pixel feather and adjust the brightness using the Curves adjustment feature.

☐ BRIGHTENING TEETH

Smokers, tea and coffee drinkers, and elderly people often have stained or discolored teeth. They are usually very self-conscious about that. So let's fix that too!

Again, work at a level of magnification that is suitable, say 200 percent.

<div style="float:left">SMOKERS, TEA AND COFFEE DRINKERS, AND ELDERLY PEOPLE OFTEN HAVE STAINED OR DISCOLORED TEETH....</div>

1. Select the Lasso tool, then enter a Feather amount of 1 to 2 pixels to select the teeth (see fig. 7.28 on page 68). Make a careful selection of all the teeth (or the discolored one[s] if they are not all the same).

2. Use the Curves adjustment feature (Cmd/Ctrl+M) to lighten the teeth.

When you have completed these steps, zoom out to 100 percent to review your results.

Warning! Do *not* make the teeth too white. It is very easy to get your client's teeth worthy of a spot in a toothpaste commercial, but the results won't look natural. You only want to whiten them a little, just enough so that your client won't notice the change, but will think that you're a wonderfully talented photographer.

☐ SMOOTHING THE FRIZZIES

Very few clients have perfect hair when they walk in to the studio. If your client has frizzy hair (see fig. 7.29), your best option is "pre-touching," or combing/straightening their hair for added control. But often that will not work (due to a "bad hair day"). And there are some clients—mostly men—who will freak out over the possibility of using hair spray. Soothe the rattled nerves of your client by saying, "We'll fix it in Photoshop"—and then do it!

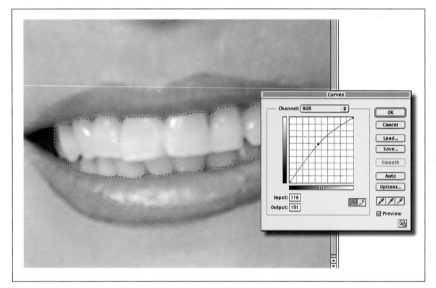

IT IS EASY TO GET YOUR CLIENT'S TEETH WORTHY OF A SPOT IN A TOOTHPASTE COMMERCIAL, BUT THE Y WON'T LOOK NATURAL.

figure 7.28

figure 7.29

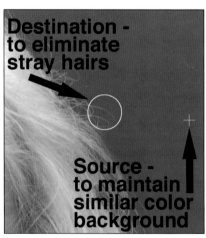

figure 7.30

This simple, quick, and much appreciated fix can be accomplished by using any one of the three retouching tools: the Clone Stamp tool, the Healing Brush tool, or the Patch tool. It doesn't require any special techniques but rather some careful attention to detail. You need to fix small areas at a time on some clients, or you will end up with some distracting, unnatural softness. The easiest way to tame unruly hair is to use the Clone Stamp tool to "clone" portions of the background, which can then be used to cover frizzy hair (see fig. 7.30).

8.
ADVANCED RETOUCHING TECHNIQUES

Some clients warrant (okay, *need!*) additional retouching to achieve the look they expect in their image. In this chapter, we will look at some techniques that can be used to add some "finishing touches" on the digital portrait.

☐ REMOVING DUST AND SCRATCHES

Regardless of how your digital file was acquired, you will discover that there is almost always a problem with dust spots in the image. But most often the worst problem comes from scanning an image. Before scanning, you should *always* take a few minutes to clean the scanner glass with a lint-free cloth and use canned air to remove any remaining dust particles. Be sure to clean your negatives or prints with canned air as well, but plan to conduct this work away from the scanner, so that dust is not inadvertently redeposited on the scanner bed! You will find that these simple steps can save you a lot of time when it comes to retouching your portraits.

REGARDLESS OF HOW YOUR DIGITAL FILE WAS ACQUIRED, THERE IS ALMOST ALWAYS A PROBLEM WITH DUST SPOTS.

If you've done your best to clean the prints, slides, or negatives, but there are still spots on the image, you could retouch them one at a time using the Clone Stamp tool (if you have no life and nothing else to do at 2:00 am!). If you need a more efficient way to "clean" the image, use the following technique.

Back to the Future. This technique has been called "Back to the Future" because it uses the History Brush tool to quickly remove dust spots from the image. First let's open our problem image—and, again, if you're scanning them, almost *every image* will be a problem (see fig. 8.1).

figure 8.1

figure 8.2

figure 8.3

1. Make a copy of the back-
ground layer (Cmd/Ctrl+J).
2. Go to Filter>Noise>Dust &
Scratches (see fig. 8.2) and
adjust the Radius and
Threshold settings to make
the medium to medium-
large spots disappear. You
will not usually be able to
remove all of them, but this

figure 8.4

procedure will take care of 99 percent of the problem (see fig. 8.3).

3. Click on the small arrow at the upper right-hand corner of the history palette and select New Snapshot (see fig. 8.4).

4. Name the snapshot "D&S" or something that indicates what it is so you don't forget. To name a layer in Photoshop 7.0, double click on the layer name in the layers palette and simply type the new name. In earlier versions of Photoshop (except in version 6.0 for the Mac), when you double click on the name, a dialogue box appears where you will type the new name and click OK. In version 6.0 for the Mac, you need to press the Opt key and click to get the dialogue box.

5. In the history palette, locate the snapshot labeled "D&S" (you may need to scroll up to find it), then click on the small box at

NAME THE SNAPSHOT "D&S" OR SOMETHING THAT INDICATES WHAT IT IS SO YOU DON'T FORGET.

figure 8.5 figure 8.6

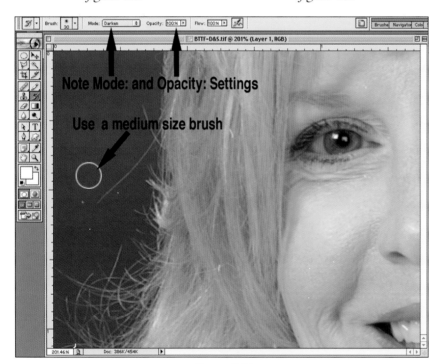

figure 8.7

the very left of the Snapshot thumbnail to set the source for the History Brush (see fig. 8.5).

6. Go back to the last History State—Dust & Scratches—in your history palette, and drag it onto the trash icon located at the bottom of this palette. The image will now appear as it did before you applied the filter.

7. Next, select the History Brush (keyboard shortcut: "Y") in your tool palette (see fig. 8.6). Use the bracket keys to select a brush size that will allow you to paint quickly but still exercise control over the area that you are painting. You may be tempted to use a very large brush and just paint everywhere, but don't.

8. Since most dust spots are lighter than the background, change the Mode of the History Brush to Darken and the Opacity to 100 percent. This is very important!

9. Now paint over all the dust spots and watch them disappear—but be careful not to paint just anywhere. While it may seem that it is not affecting the image, we want to do as little as possible to any image to maintain maximum image quality (see fig. 8.7).

This technique will save you countless hours if you scan all your images, even being as careful as possible to control the dust on the originals or the scanner.

☐ IMPROVING AND SOFTENING SKIN TONES

Now that you're an expert on the "Back to the Future" technique, let's use the same method to improve and soften skin tones on our subject. This is done in almost the same way that we removed the dust and scratches.

THIS IS A REAL MONEYMAKER AND TAKES VERY LITTLE TIME TO ACCOMPLISH. YOUR CLIENTS WILL APPRECIATE THE IMPROVEMENTS!

1. Make a copy of the background image (Cmd/Ctrl+J).

2. Go to Filter>Blur>Gaussian Blur and add enough blur to the background copy layer to soften the image quite a bit. Don't be too concerned as to whether the effect is just right, because we will control the effect later.

3. Click on the small arrow at the top-right corner of the history palette and select New Snapshot.

4. Name the snapshot "Blur" or something indicating what it is so you don't forget.

5. Click on the small box located near the very left of the Snapshot icon to set the source for the History Brush.

figure 8.8

figure 8.9

6. Go back to the last history state—Gaussian Blur—in your history palette, and drag the icon into the trash can. The image will now appear as it did before you blurred it.

7. Select the History Brush in your tool palette (keyboard short-cut: "Y"). Then select a brush size appropriate to the area you are working on to clean up the skin. Use a large brush for cheeks, forehead, or the chest, and a smaller one for under the nose, around the eyes, etc. To change the brush size use the bracket keys; to adjust the softness of the tool, click the bracket and the Shift key simultaneously.

8. Set the Mode to Normal and the Opacity to 100 percent.

9. Now paint in the blurred skin on the sharp image. Too much softness you say? Not to worry! (See fig. 8.8.)

10. Once complete, lower the opacity of the blurred layer until you are happy with the results (see fig. 8.9).

USE A LARGE BRUSH FOR CHEEKS, FOREHEAD, OR THE CHEST, AND A SMALLER ONE FOR UNDER THE NOSE, AROUND THE EYES, ETC.

This technique is also a real moneymaker and takes very little time to accomplish. Your clients will certainly appreciate the improvements! This technique is applicable to both male and female clients to different degrees.

CLASSIC DIFFUSION

For years we have been searching for the perfect amount of diffusion and the perfect diffusion filter. Marketing has convinced us that there really are some, but we know that regardless of how "perfect" they are, they are sometimes too soft or not soft enough. Never satisfied, are we? This technique, called Classic Diffusion, lets us control the amount of diffusion and even *where* it is applied, allowing us to maintain a degree of sharpness in the eyes, lips, hair, clothing, whatever! This technique is primarily for use on portraits of women, giving a soft, glamorous look to an image.

The first step in this process is the same as always: Make a copy of the background layer. But this time we will make two copies. To do this quickly, simply use the keyboard shortcut Cmd/Ctrl+J—twice—and you will have two background copies. Now let's create a wonderful effect.

1. Make the top layer active and apply a blur (Filter>Blur>
 Gaussian Blur) that suits the resolution of your image.
 A setting of 4 or 5 pixels is a good bet for a 300 ppi
 image (see fig. 8.10).

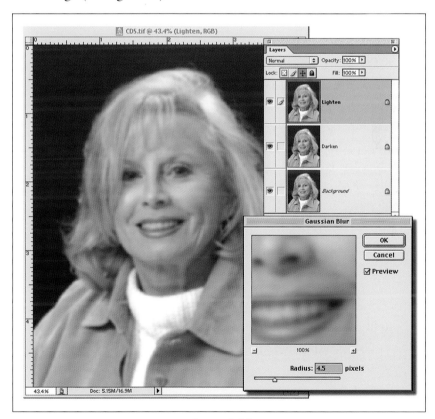

figure 8.10

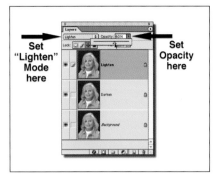
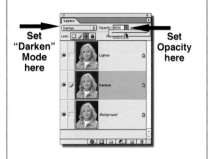

Set "Lighten" Mode here — Set Opacity here

Set "Darken" Mode here — Set Opacity here

figure 8.11　　　　　　　　*figure 8.12*

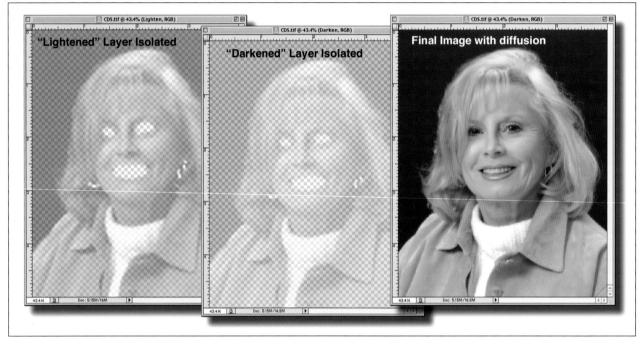

figure 8.13

2. In the layers palette, change the Mode of your layer to Lighten and the Opacity to 60 percent (see fig. 8.11). Name this layer "Lighten."

3. Make the second layer active and apply the same amount of blur, but this time use the shortcut Cmd/Ctrl+F to reapply the last filter used to the same degree.

4. Change the Mode of this layer to Darken and the Opacity to 40 percent. Name this layer "Darken" (see fig. 8.12).

5. After selecting the Eraser tool (keyboard shortcut: "E"), make the "Lighten" layer active and erase the eyes, lips, and anything else you want to sharpen up (see fig. 8.13).

6. Go to the "Darken" layer and do the same thing you did on the "Lighten" layer, erasing those parts you want to keep sharp.

And that's that! Your controls with this technique are the amount of diffusion (blur) you apply to each layer and how much you erase to expose the sharp layer below. This finished image is the one on the right in figure 8.13.

☐ WANT INSTANT WEIGHT LOSS? LIQUIFY!

How many times have you heard a client say, "I have to lose some weight before I schedule an appointment for my portrait"? Well that excuse just went out the window with Photoshop and the following technique!

The Liquify tool is the answer. Sometimes called the Distort tool, it was first used in a program called Live Picture® and was later adopted by Photoshop. The Liquify tool is used to move pixels around without destroying the integrity of the image like the Smudge tool does. Though it can be used for many creative effects, we are not being creative with our digital portrait yet. We are trying to make our clients look the way they think they look or want to look, and for that reason, this tool is a moneymaker!

You can find the Liquify tool under the Filter menu (see fig. 8.14). When you open the Liquify tool, a dialogue box will appear, presenting you with several useful options. The tool you will use the most is the Warp tool, which is found at the top of the tools palette inside the dialogue box (keyboard shortcut: "W" inside the box). This is the tool used to reshape images. I also call it the "scootch" tool (that's southern for moving things only a little bit!) because I can scootch pixels around with it.

Most of the default options set in the left-hand side of the Liquify dialogue box are fine as is, so we're not going to spend a lot of time here.

THE LIQUIFY TOOL IS USED TO MOVE PIXELS AROUND WITHOUT DESTROYING THE INTEGRITY OF THE IMAGE....

figure 8.14

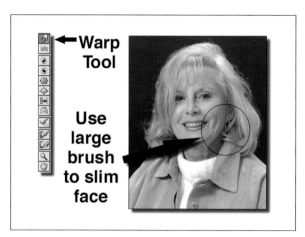

figure 8.15

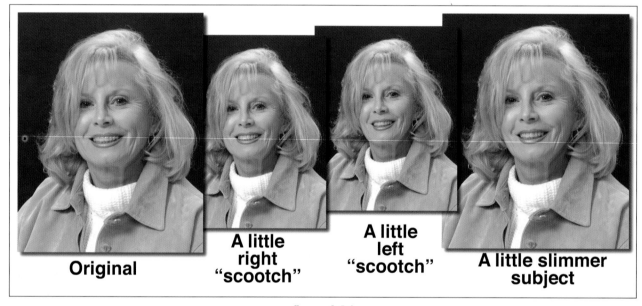

figure 8.16

Now, let's take a few pounds off our subject:

1. Go to Filter>Liquify.

2. Select the Warp tool (keyboard shortcut: "W").

3. Select a large brush, close to the size of the client's face (see fig. 8.15). You can change brush sizes using the menu or, again, can make brush size adjustments by using the bracket keys.

4. Click and "scooth" a little on one side of the face, but do not paint! Notice how the edges remain very close to the original, but the face has been made slimmer. Continue to do this until one side the face is to your satisfaction.

5. Now do the other side of the subject's face to match! (See fig. 8.16).

You can also use this technique on a full-length portrait to slim the waist, hips, thighs, etc.—but how much is enough? You'll know that the image looks just right when the client likes it!

Now let's look at some of the other tools available in the Liquify dialogue box. While most of these have extremely limited use in portraiture, it doesn't hurt to be aware of the way they function! (See fig. 8.17.)

Note: To use the shortcuts provided below, be sure that the Liquify dialogue box is active!

Turbulence tool (keyboard shortcut: "A")—Creates a wavy effect, not used in retouching.

Twirl Clockwise tool (keyboard shortcut: "R" for "Right")—Does just that, not used in retouching.

Twirl Counterclockwise tool (keyboard shortcut: "L" for Left)—Same as above but backward, not used in retouching.

Pucker tool (keyboard shortcut: "P")—"Pinches" the pixels.

Bloat tool (keyboard shortcut: "B")—"Bloats" the pixels.

Note: The Bloat and Pucker tools can be useful if used *very* judiciously. For example, an eye that is too large can be made slightly smaller with one click of the Pucker tool. Conversely, you can use the Bloat tool to slightly open an eye, but be careful! One click and you're done (maybe two, but no more). The Bloat tool can be used to enhance (i.e., digitally increase the size of) other parts of the body as well—at your client's discretion.

Shift Pixels tool (keyboard shortcut: "S")—This tool just moves pixels around somewhat randomly and is not useful in retouching.

figure 8.17

Reflection tool (keyboard shortcut: "M"—I didn't make these up!)—Mirrors the selected pixels. Not used in retouching.

Reconstruction tool (keyboard shortcut: "E" like the Eraser)—Reconstructs the image a little at a time but often it is better to just start over!

Freeze tool (keyboard shortcut: "F")—makes selected areas "frozen" so you cannot disturb them while using any of the other available tools.

Thaw tool (keyboard shortcut: "T")—Thaws or "unfreezes" frozen areas so you can distort them.

Zoom tool (keyboard shortcut: "Z")—Zooms in and out. Default is "+" to zoom in. Hold the Opt/Alt key to zoom out.

Hand tool (keyboard shortcut: "H")—Works just like the Hand tool in the normal tools palette. You can use this tool to move the image around so you can see different areas of the image once you are zoomed in.

9.
USING SELECTIONS FOR CONTROLLED EDITING

▣ THE ROLE OF SELECTIONS

Using any of the Adjustment features affects the entire image. This is called "global" correction. To correct specific areas, called "local" correction, you must first make a selection. Why make local corrections? Well, if everything in an image is correct in color or tonality with the exception of a subject's face, for instance, making a selection will allow you to select the face and apply additional corrections to that area without affecting the remainder of the image. Of course, this opportunity to make local corrections is not limited to faces. It can be used to make changes to clothing, background, eyes, etc.

While making good selections is a topic worthy of a book in itself, for this discussion, we are going to cover a few essential techniques for making and controlling them.

You will normally make a selection using the Marquee tools (for rectangular or elliptical shapes) or the Lasso tools (best with irregular shapes). When you make a selection, marching ants surround the precise area that you have defined (see fig. 9.1)—*unless* you have feathered the edges of the selection (more on this topic in a minute).

▣ FEATHERING SELECTIONS

When you select the Marquee or Lasso tool, the Options bar will feature a box labeled Feather that prompts you to enter a value in pixels. In "feathering" your selection, the sharp edge of the defined selection becomes blurred—either a little or a lot, depending on the value you type into the box. Feathered selections have soft edges and blend your corrections into the image, making them appear more natural.

USING ANY OF THE ADJUSTMENT FEATURES AFFECTS THE ENTIRE IMAGE. THIS IS CALLED "GLOBAL" CORRECTION.

While you can enter a feathering value before or after you make a selection, keep in mind that the marching ants will not define your selection with 100 percent accuracy. If you make a selection, feather it, and apply an effect, you will notice that the feathered area that extends just beyond the marching ants is affected by your action. If you require a more precise way to visualize the area in which you will be working, there is a better way to view the actual selection. First, make a copy of the background layer, then make your feathered selection on this layer and select the Quick Mask option. To do this, you can either click on the Quick Mask icon, which is found immediately below the Foreground/Background colors (see fig. 9.2), or you can simply type the letter "Q." Either way, you will see a transparent red overlay that will indicate the masked (or nonselected area) with the clear, non-masked area indicating your selection. This will give you a better indication of what is actually selected and how the feathering amount "fades out" to blend with the background. (Some Photoshop users prefer to see the *selected* area in red; if this option appeals to you, double click on

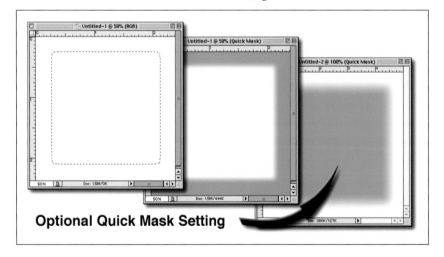

figure 9.2

the Quick Mask icon, and you will be given options to change the color of the overlay, the opacity of the overlay, and if it indicates the selected area or the masked area [see fig. 9.3].) If you are not satisfied with the degree of feathering you've selected, you can increase the effect by applying a blur. To do this, go to Filter>Blur>Gaussian

figure 9.3

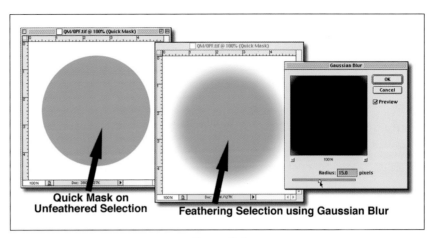

figure 9.4

figure 9.5

figure 9.6

Blur. You will see the selection become blurry, indicating that the feathering has occurred (see fig. 9.4). Once you are satisfied with the results, click on the Edit in Standard Mode icon, located to the left of the Quick Mask icon in the tools palette—or press "Q" once more to exit Quick Mask mode.

A second method of accurately visualizing a feathered selection is to make a selection and then save it (Select>Save Selection). You will be prompted to name the channel you will be creating (see fig. 9.5). If you *don't* name it, it will automatically be called an Alpha Channel and numbered chronologically (i.e., Alpha 1, Alpha 2, etc.). Regardless, you will see the result of the selection in the channels palette. If you click on the channel (not on the eyeball icon to the left of the channel) a black & white image that depicts your selection will appear on your monitor in place of the original image (see fig. 9.6). This image will help you to visualize what the selection looks like—your selection will appear in white, and areas not selected will appear black; any gray areas of the image (like the feathered edge of your selection) are partially selected (based on how dark gray they are).

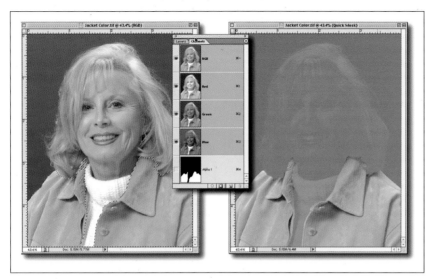

figure 9.7

figure 9.8

If you have the channel active, you can blur it or add filters, paint on it with black to conceal more of the image or with white to reveal more. You can also paint with either white or black at a lowered opacity (meaning a gray tone) to partially conceal or reveal a particular portion of your image. And if the composite (top) channel in the channels palette is active and you click on the Alpha Channel eyeball, you will see the same red mask as if you used the Quick Mask option (see fig. 9.7). So we're back to where we started (see fig. 9.8).

COMPOSITING IMAGES

☐ THE EXTRACT TOOL

While the Extract tool (Filter>Extract) is not something you will use often, it can be used effectively to realistically place a person into an existing image (i.e., adding an individual to an existing group, or removing an individual from one background to put them in a more interesting scene). No matter what your objective, the secret of using the Extract tool effectively is advance planning.

This tool tells Photoshop what your background consists of so that it can throw it away. It is also used to define your foreground or subject—in other words, what information it should keep. Finally, Photoshop must determine how to best define a "transition" area between the desired image component and the background area to be eliminated. While this may sound simple, it's not! But Photoshop does a good job under the right circumstances.

☐ ADVANCED PLANNING

For the best results, photograph your subject against a "clean," solid, and preferably neutral-colored background. This is where the planning comes in. If you photograph a blond subject, do it against a dark gray or black background. Photograph a brunette against a light gray or white background. If the subject you want to move to a new scene was photographed against a complex, multicolored background, you might as well not mess with this tool. In this situation, you'll need to do a *lot* of work, and you'll achieve less-than-satisfactory results. *Hint:* If your subject has thin hair that you can see through, then you are well-advised to photograph him or her against a background of the same color as the

PHOTOGRAPH YOUR SUBJECT AGAINST A "CLEAN," SOLID COLOR, AND PREFERABLY NEUTRAL-COLORED BACKGROUND.

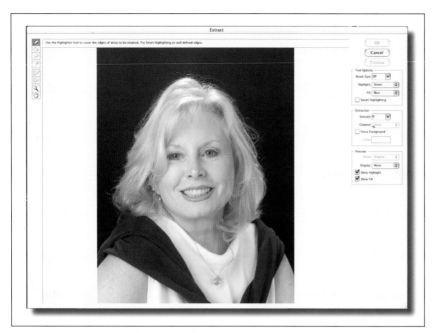

figure 10.1

Edge Highlighter Tool (B)

Fill Tool (G)

Eraser Tool (E)

Eyedropper Tool (I)

Cleanup Tool (C)

Edge Touchup Tool (T)

Zoom Tool (Z)

Hand Tool (H)

figure 10.2

one used in the final image. This way, you will not be forced to contend with having bits of the old background showing through in the composited image.

To extract your subject from the background, follow these steps:

1. Make a copy of your background layer.

2. Go to Filter>Extract. A dialogue box will appear with your image in it (see fig. 10.1). Select the Edge Highlighter (keyboard shortcut: "B") from the left-hand side of the dialogue box (see fig. 10.2). This tool will be used to outline your subject and will also create a transition between the person and the background we want to eliminate. In completing this step, be sure that any background that touches your subject is minimally covered by the Edge Highlighter. Use a large brush (or multiple strokes with a smaller brush) to cover the hair and any background that shows through. Use a smaller brush (as small as possible) to outline sharp transition areas like skin or clothing. You may choose the Smart Highlighting option, which is found on the right-hand side of the Extract tool dialogue box (see fig. 10.3). It works much like the Magnetic

USE A SMALLER BRUSH (AS SMALL AS POSSIBLE) TO OUTLINE SHARP TRANSITION AREAS LIKE SKIN OR CLOTHING.

<div style="text-align:center">figure 10.3 figure 10.4</div>

Lasso in that the outline you create will adhere to the subject's outline as you drag the tool across the subject's edges—but it will minimize the brush size automatically. Try to keep about one-third of the highlight on the subject and two-thirds on the background for best results.

3. Once the subject is outlined, you can fine-tune your high-lighting. Zoom in close and check to make sure that:

a) all of the edge of the subject that you want to keep is covered by the green highlight. This includes any "stray" or wispy hairs that you may want to keep (see fig. 10.4).

b) all of the background that touches your subject is also cov-ered. It is important that any "pieces" of the background (pix-els of the same color/tonality) that show through the hair are also covered by the green highlight.

c) you connect the starting and ending points of the highlighter or that it touches the edges of your image so that when you fill the selection in step 5, the fill color does not spill into the area you want to eliminate. *Note:* The default color of the Highlight Edge tool is bright green. If for some reason you are working on an image with a similar background color, you can change the highlighter's color to something that creates better contrast, allowing for the best possible selection. Just choose a new color from the menu on the right-hand side of the dialogue box.

4. Now, examine your work. If you think that there is too much highlighting in certain areas, use the Eraser tool to erase unnecessary coverage.

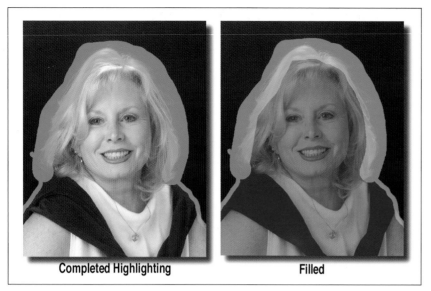

Completed Highlighting **Filled**

figure 10.5

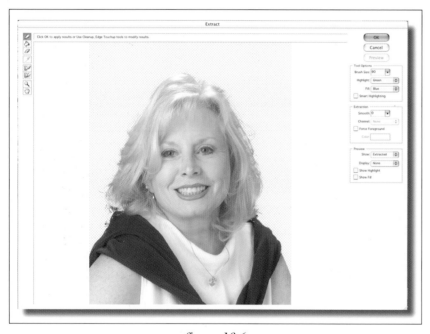

figure 10.6

ONCE YOU HAVE PAINTED
AROUND THE WHOLE IMAGE,
SELECT THE FILL TOOL AND CLICK
INSIDE THE HIGHLIGHTED AREA.

5. Once you have painted around the whole image, select the Fill tool (keyboard shortcut: "G") and click inside the highlighted area (see fig. 10.5). This will fill the area and tell Photoshop to keep this information. If the entire image becomes blue (the default fill color), the fill "leaked" out because you did not connect your start and end points or outline slightly beyond the edge of your image. *Note:* The Eraser tool used in step 4 only erases the green highlight; if you use the tool after you have filled the selection, you will "unfill" it so you can go back and erase the highlight.

6. With the above steps complete, click on "Preview" and you will see the "extracted" view of your image against a transparent background (see fig. 10.6). You can now select a background color against which to view your image by selecting a Display option in the Preview menu on the right-hand side of the dialogue box. You have a choice of None (which is the default), White, Gray, Black, or Other. Choosing "other" will allow you to select any color you want from the Color Picker dialogue box. This will give you the first opportunity to see how well the extraction worked on this image (see fig. 10.7). Remember, less-than-perfect extractions can be hidden by the right background, and this is where the advanced planning comes in handy.

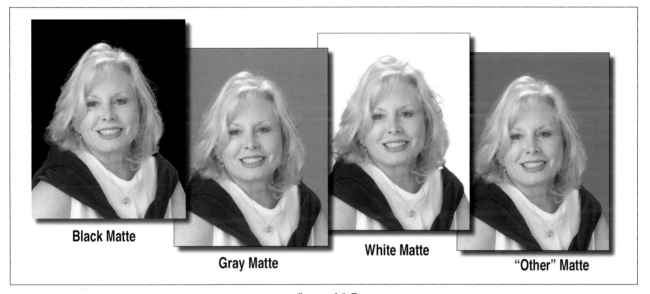

Black Matte **Gray Matte** **White Matte** **"Other" Matte**

figure 10.7

7. If the extraction did not work out as you had hoped, you can still make some corrections before clicking OK. The Cleanup tool (keyboard shortcut: "C") is used outside the image to clean up any miscellaneous pixels that you want to eliminate. It works like Photoshop's Eraser tool, sort of (see fig. 10.8). The Edge Touchup tool (keyboard shortcut:

figure 10.8

figure 10.9

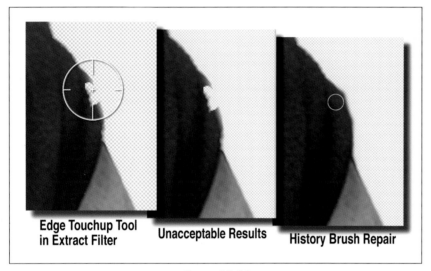

Edge Touchup Tool
in Extract Filter — Unacceptable Results — History Brush Repair

figure 10.10

"T") is used inside the image to touchup the edges of the
image. It works like the History Brush tool—sort of (see fig.
10.9). Both these tools do what their name implies, but are
somewhat constrained in that they affect one part of the image
more than the other. It takes some experience to make these
tools work as well as you'd like them to.

8. The final step in the extraction is to click OK. If you notice
any image flaws, like missing parts of clothing, you still have
the opportunity to use the History Brush tool to correct
them—but only if you have not cropped your image before
working with this tool. *Note:* In figure 10.10, we tried to fix a
glitch in the subject's sweater using the Edge Touchup tool,
but it did not work well at all in this case. So we applied the
Extract filter anyway and, back in Photoshop, made sure the
source for the History Brush was the original image (you will
need to select the cropped image as your source if you

IT TAKES SOME EXPERIENCE
TO MAKE THESE TOOLS WORK
AS WELL AS YOU'D LIKE
THEM TO.

cropped your image before this step) and then painted the good sweater detail back into the image. In time, you will learn to create a New Snapshot when working with the Extract tool! Of course, this problem won't concern you if you make it your policy to not crop anything until the very last step.

Now that you have extracted your image and are happy with it, you have a lot of options as to what you do with it. Our subject wanted a portrait on the tennis courts, so we put her in a stock image of a tennis court and never even messed up her hairdo (see fig. 10.11). To combine images, I made the extracted layer in the "portrait" image active, selected the Move tool, clicked on the subject's face, and dragged her over to the new background image. When you try this yourself, be sure to drag all the way into the new image before letting go of the mouse. While the extracted image may seem to stop at the edge of the new

NOW THAT YOU HAVE EXTRACTED YOUR IMAGE AND ARE HAPPY WITH IT, YOU HAVE A LOT OF OPTIONS....

figure 10.11

figure 10.12

background, it doesn't. Trust me here! Keep dragging and you will see a box in the background image; then just let go of the mouse button, and you're done!

☐ SWAPPING EYES AND FACES

How many times have you photographed a subject and found that the smile was great but the eyes were closed or partly closed? While this can be a concern in a single-subject portrait, the odds are higher in a two-subject or group portrait. Fortunately, Photoshop allows you to composite the best aspects of two or more images to create one perfect portrait!

The basic premise of this technique is copying the information in one image and putting it into another one. There are many ways to do this, all of which are simple and have their place.

Our two images are both of the same person. However, the smile in one is good but her eyes are not. The other has good eyes but the smile is not as good. So we are going to swap the eyes from one image to another to fix that problem (see fig. 10.12). The secret to making this easy is, of course, choosing images with the same or very similar head positions in each image. Can we do it otherwise? Certainly! But it will be somewhat more difficult. If you decide to use images with different head positions, it's important to find two images that have similar lighting qualities and directions. What do I mean by "quality?" For example,

PHOTOSHOP ALLOWS YOU TO COMPOSITE THE BEST ASPECTS OF TWO OR MORE IMAGES TO CREATE ONE PERFECT PORTRAIT!

a studio portrait taken with soft light will not match up with an outdoor portrait taken in direct sunlight, so if these elements are combined, the final image will not look real. In our examples, we are going to take the eyes from the image on the left and put them in the image on the right with the good smile.

...MAKE A LOOSE SELECTION AROUND THE HEADS OR FACES YOU WANT TO USE AND MOVE THEM TO THE OTHER IMAGE.

1. Activate the image with the good eyes by clicking on it.
2. Get the Lasso tool (keyboard shortcut: "L"), and set the Feather Radius at about 3 pixels.
3. Make a loose selection around the eyes. It does not have to be close, because we will be making adjustments in the good image (see fig. 10.13).

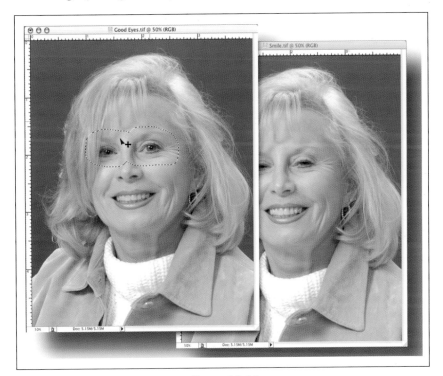

figure 10.13

4. Select the Move tool (keyboard shortcut: "V") and put the cursor inside the selection (marching ants) as in figure 10.13. Make sure that you have selected the Move tool; otherwise, you will simply move the selection, not the information you want to use.
5. Next, click, hold, and drag the selected area out of the image and into the one you want to fix. Note that when the outer edge of the image changes color, you're there, and all you need to do is "drop" the selection (let up on the mouse button). You will notice that when the eyes are moved, there will be a hole where they were in the original image. This will

automatically be corrected when you drag the eyes into the new image. Also note the darkened border around the target image, showing that you have entered into the target image space and the eyes will be "deposited" as a new layer in that image (see fig. 10.14).

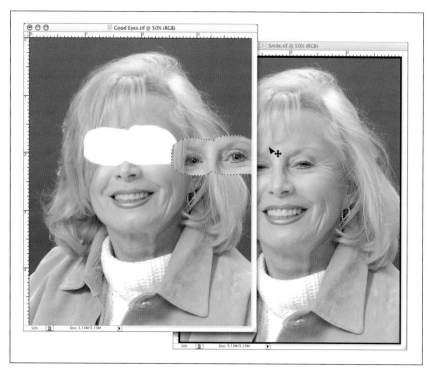

figure 10.14

figure 10.15

...YOU HAVE ENTERED INTO THE TARGET IMAGE SPACE AND THE EYES WILL BE "DEPOSITED" AS A NEW LAYER IN THAT IMAGE.

figure 10.16 *figure 10.17*

6. Note that there is now a second layer in the image you dragged the eyes to, and that layer contains only the eyes from the other image. This new layer is automatically created by Photoshop and is the active layer (see fig. 10.15). Note that the drop shadow around the eyes in the new layer in my image is shown here for effect only—they will not appear in your images!

7. With the Move tool, move the new eyes roughly into position over the old ones.

8. Change the Opacity of this layer to about 50 percent and make your final alignment, putting the eyes exactly where they should be (see fig. 10.16).

9. Change the layer Opacity back to 100 percent.

10. Use the Eraser tool (keyboard shortcut: "E") to erase the sharp edges around the new eyes until the new portion blends into the background, then use a soft brush to further blend the two elements. If you note a difference in color or tonality between the eyes and the rest of the image once the blending is complete, you will need to use the Curves adjustment feature to create a better match. Note how the layer looks by itself after I finished blending the images together with the Eraser tool (see fig. 10.17).

11. The final step is to flatten the image, because there is no need to keep the layers.

But What If . . . ? What if the eyes you are moving are a different size or have a different tilt than the ones you are replacing? No problem. Just use the Free Transform tool (Edit>Free Transform) to change the

figure 10.18

size and/or angle of the replacement eyes to match the original. Hold the Shift key down and drag only the corner handles of the bounding box while changing sizes so that you will constrain the proportions and not stretch the new eyes out of shape (see fig. 10.18). If you move the cursor outside the bounding box, you will note that the cursor changes to angled arrows, indicating that if you click, hold, and drag the mouse, the image will be rotated. With this accomplished, go back to step 8 above and complete the change.

What about heads (or even just an expression)? These changes can be made in the exact same way. With two images of the same group open, make a loose selection around the heads or faces you want to use and, with the Move tool, move them to the other image. Align them using the same technique shown above, resizing and rotating if necessary to make them match.

11.
FLATTENING AND SHARPENING

Having worked your way through the various techniques outlined in this book, you are now ready to flatten and sharpen your image. Before moving on, however, remember that your goal in making image enhancements should be to minimize what you do to any image and ensure that you have the flexibility to make future changes. Let's look at what we need to do to retain this control:

1. Remember, never work on the original image. Always make a copy of it and keep the original image intact and on file.
2. Do all retouching on separate or copy layers.
3. Save your uncropped, unflattened, and unsharpened image as a PSD file so that you can make any necessary changes to it down the line. Next, save a copy of the image using whatever file format best suits your client.

Now let's complete the steps necessary to finish our image and get it ready for delivery to a client.

> NEVER WORK ON THE ORIGINAL IMAGE. ALWAYS MAKE A COPY OF IT AND KEEP THE ORIGINAL IMAGE INTACT AND ON FILE.

☐ FLATTENING YOUR IMAGE

Flattening an image means compressing all the layers into one so that we have only a background and no layers; taking this action also commits all the corrections made to the image. You have two choices as to how to do this (there is no keyboard shortcut!):

1. Click on the right-facing arrow at the top of the layers palette and then on Flatten Image (see fig. 11.1 on page 98).

2. Go to Layer>Flatten Image in the Options bar at the top of your screen.

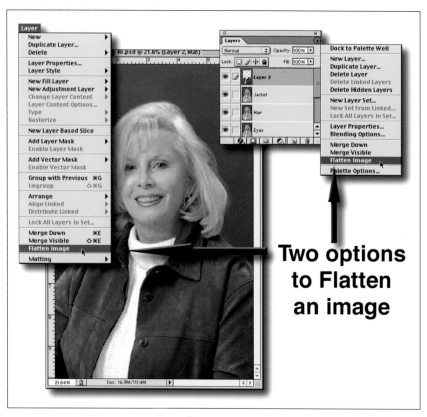

figure 11.1

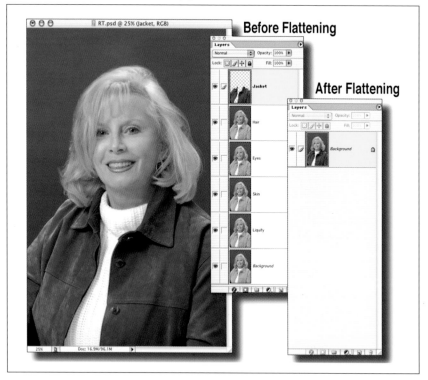

figure 11.2

In the photo examples in figure 11.2, the layers palette on the left is from the layered PSD file, and the layers palette on the right is from the flattened version, which can be saved as a JPEG or TIFF file. While you can save a layered image as a TIFF, I suggest you save it as a PSD. Photoshop documents were designed to maintain layers, and this designation will help you to easily determine which of your files contain layers. You cannot save an image as a JPEG if it has layers or channels (see fig. 11.2).

◻ SHARPENING YOUR IMAGE

Most images will need some degree of sharpening, but how much depends on several things. As a general rule, portraits need less sharpening than other types of images.

To sharpen an image you will apply an Unsharp Mask. (The name Unsharp Mask comes from the printing industry where fuzzy [or "unsharp"] areas of an image were masked to make it appear sharper.) The Unsharp Mask is found in the Filter menu (Filter>Sharpen> Unsharp Mask) (see fig. 11.3). You will note that the Unsharp Mask option is followed by three dots, which indicate that you will need to make some choices about how the tool is used.

IN GENERAL, LOW RESOLUTION IMAGES REQUIRE LESS SHARPENING THAN HIGH-RESOLUTION IMAGES.

figure 11.3 *figure 11.4*

In the dialogue box, you will see that you have three options: Amount, Radius, and Threshold (see fig. 11.4). All three of these options will affect the amount of sharpening applied. In general,

- low resolution images require less sharpening than high-resolution images.
- smaller images require less sharpening than larger ones.

- portraits require less sharpening than other photographs
- images output on a printing press require a greater degree of sharpening than those printed by other means.

The majority of my images are 8x10 inches; for these portraits, I set an Amount of 100 percent, a Radius of 2.7 pixels, and a Threshold of 2. If you sharpen too much, the image will develop a "halo" around the edges, and your work will be obvious.

Sharpening is *not* intended to fix fuzzy images but rather to eliminate much of the inherent unsharpness of images captured on a digital chip. However, it *can* help slightly fuzzy images become acceptably sharp, to a point.

12.
CROPPING

Photoshop's Crop tool allows you to remove extraneous portions of your image, allowing you to draw the viewer's attention to the portion of the image that matters most—the subject. Before proceeding, however, there are some important points to consider.

☐ A WORD TO THE WISE

Be forewarned: The Crop tool gives you several options, but let's not use them until we're ready. Meaning what? Meaning that once you crop your portrait, it will never again be the same if you need to create a larger image.

When you capture or scan an image, your original file contains a great deal of data. Remember that in retouching an image, there is a chance that its quality can suffer. Therefore, we want to minimize what we do to any image in Photoshop (that was a hard lesson learned!). Take this advice: *do not* crop your working image until you are ready to deliver it. While this is an important rule in portraiture, it is especially vital in wedding images.

Imagine the following scenario:

The Smith family wants a 5x7-inch portrait of their son, Thomas. To fill their order, you crop the original file to 5x7 inches in Photoshop. The next thing you know, Mrs. Smith calls to tell you that she and her husband actually prefer an *8x10-inch* print. No problem, right? You can once again select the Crop tool, enter 8 and 10 in the Width and Height boxes, and resize your image, right?

Well, here's the bad news: Because the aspect ratio of an 8x10-inch print is different from that of a 5x7-inch print, some of the image data

WHEN YOU CAPTURE OR SCAN AN IMAGE, YOUR ORIGINAL FILE CONTAINS A GREAT DEAL OF DATA.

was thrown away when the image size was reduced. In fact, in enlarging the cropped image back to its original size, you may find that the initial crop has negatively affected the composition of the "new" 8x10-inch print that your client is expecting.

☐ USING THE CROP TOOL

Once you're certain that you're ready to crop your image, click on the Crop tool in the tools palette (see fig. 12.1). With the tool selected, you will note several options in the Options bar (see fig. 12.2). On the far left you will find a Crop tool icon, and beside it, an arrow. This is where tool presets are stored: this handy option allows you to store the cropping specifications you use most often, so that you can make a selection in this menu and make quick work of the cropping (more on this in just a second). To the right, you'll find the Width, Height, and Resolution fields.

figure 12.1

Presets. If you commonly produce 8x10-inch prints at 300 ppi, you can create a preset for this image type. To do so, enter the corresponding numbers (i.e., 8, 10, 300) in the Width, Height, and Resolution boxes. Next, click on the arrow found alongside the Crop tool (in the Options bar), then click on the Create New Tool Preset button (or click the right-facing arrow and select this option from the pop-up menu). With the click of a button, Photoshop will create a cropping shortcut: just click OK, and the selections you set will become a readily-available preset that you can use any time you use Photoshop. To accept this setting, just click OK. *Note:* While Photoshop will assign a name for this preset, you can change it if you like.

THIS HANDY OPTION ALLOWS YOU TO STORE THE CROPPING SPECIFICATIONS YOU USE MOST OFTEN....

To use one of your presets for your next cropping job, just click on the arrow alongside the Crop tool icon, then select the specific preset you want to use. When you use your Crop tool, your cropping marquee, and thus, your selection, will be constrained to the proportions that you previously set (these settings will appear in the Width and Height boxes). *Note:* Clicking the Current Tool Only box will streamline your presets menu. With the box unchecked, this menu will display presets for not only the Crop tool, but for others as well (see fig. 12.2).

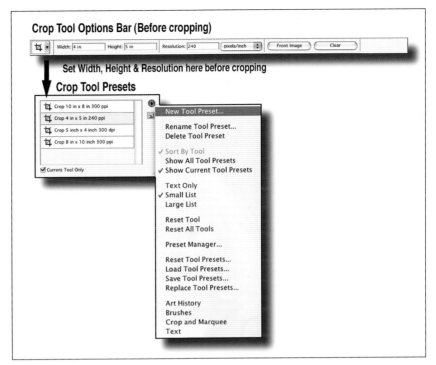

figure 12.2

Without using the preset function, you can type in any numbers you need in the Width, Height, and Resolution boxes, and the Crop tool will apply them when you click, hold, and drag out the crop bounding box in your image.

More on Cropping. While setting presets that you will use to crop images to the sizes you produce most often can be helpful, you can also crop your images without them. To do so, just enter

figure 12.3

THE AREA THAT YOU INTEND TO CROP OUT DOES NOT NEED TO BE PERFECTLY DEFINED AT THIS POINT....

the appropriate figures into the Width, Height, and Resolution fields in the Options bar, then use your Crop tool to select the area of the image you wish to keep.

If you have several images in which you want to retain the same relative sizes of the subjects but eliminate extra background information, use the Crop tool without any size settings.

So let's crop our image and see what happens next. With the Crop tool (keyboard shortcut: "C") selected, click on the image and drag across it to make a selection. The area that you intend to crop out does not need to be perfectly defined at this point, because you can make

adjustments later. When you let go of the mouse button, the area to be cropped out will be covered by a shield (see fig. 12.3 on page 103). You can change both the opacity and the color of this shield to suit your needs.

Cropping Images with Layers. If you are cropping an image with layers, you will also note that you can select either Hide or Delete in the Options bar (see fig. 12.4). The Delete option is self-explanatory; it allows you to immediately delete the area you wish to crop out. When the "Hide" option is selected, the background layer is cropped, but the overlying layers remain intact, though some of the image data will now protrude beyond the visible areas of the image. To see this data, use the Move tool to reposition the layer. As you can see, this option allows you some flexibility in finessing the image.

Wouldn't it be nice if you didn't have to have a layer to do this? Say yes! You can use the option if you simply double click on the background layer in the layers palette. A dialogue box will appear, the name of the layer will automatically be changed to "Layer 0," and you will be able to select either the Hide or Delete option (see fig. 12.5).

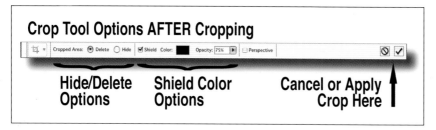

figure 12.4

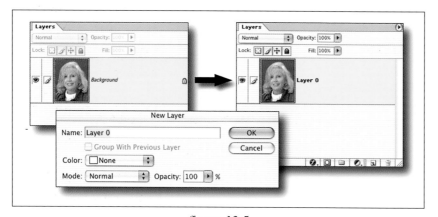

figure 12.5

Perfecting the Crop. Okay, you've cropped your image and now you want to adjust the crop to make it "perfect." Here are your options:

1. To move the marquee to another position, place the cursor inside the crop box and drag the box to change its location.

2. To change the dimensions and shape of the crop box, drag a corner handle. If you like the shape but not the size, hold down the Shift key as you drag a corner box and the proportions will remain the same as the size changes. Note that this option will not be available if you have cropped the image to a specific proportion (like an 8x10-inch print).

3. To rotate the crop box, position your cursor outside of the box and move your cursor clockwise or counterclockwise. You will notice that the cursor, placed in this way, takes on the shape of a curved arrow and that the crop box rotates about the center of the box. (If you look closely, you can see the point of rotation in the center of the crop box. You can move this point [the point of rotation] by putting your cursor on it [note the change in the cursor!] and dragging it to another location. This works the same way when using the Free Transform feature.)

Once you have the crop box positioned to your liking, you are ready to apply the crop. Either hit the Return key or double click inside the crop box and it shall be done!

Matching Original Image Specifications. If you wish to crop an image to the same size and resolution but change the contents (what you see of the image), click the Front Image box in the Options bar. If you click on Clear, all specifications or preset sizes will be eliminated, and you can crop the image to any shape you want without changing the resolution. Note that when you use the Crop tool without any set sizes or resolutions, the size and resolution of the *subject* in the image will not change but the physical dimensions of the image (height and width) will.

figure 12.6

Correcting Perspectives. The Perspective option is a very useful feature in the Crop tool Options bar (see fig. 12.6). With this box checked, you can move the cursor over one of the corner handles and it will change from a "two-way" arrow to a "shaded" version. Click and drag on a corner point, and only that particular point will move, changing the angle of the edge of the box (see fig. 12.7 on page 106). When you apply the crop, Photoshop will automatically make the edges square and change the image so that it corrects some distortion. While this feature

...PHOTOSHOP WILL MAKE THE EDGES SQUARE AND CHANGE THE IMAGE SO THAT IT CORRECTS SOME DISTORTION.

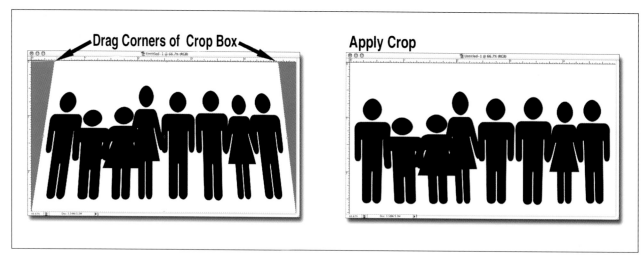

figure 12.7

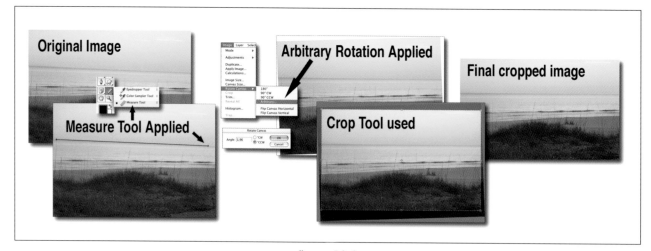

figure 12.8

is powerful and mostly used for more commercial images (such as correcting architectural perspective), you can use it to correct the same distortion that is found when shooting large groups from a high angle with a wide angle lens.

Here's a cool tip: By rotating the crop box, you can correct a tilted horizon or purposely add additional "distortion" to an image for an arty effect. It's simple to accomplish: just rotate the box to make the horizon straight, right? Well, making it exactly level is pretty tough—and trying to do so can be pretty tedious with the Crop tool. So here is the secret (and it doesn't lie in using the Crop tool): Find the Measure tool—a ruler-shaped icon that's found by clicking on the Eyedropper tool (see fig. 12.8). In your image, click on one side of the visible horizon (the cross is the point of measure) and drag as far as you can, letting the mouse button go after you align the cross on the horizon. You will see several measurements in the Options bar—but don't pay them

any attention. Instead, go to Image>Rotate Canvas>Arbitrary; a dialogue box will appear that contains the specific amount of rotation needed plus the direction in which the image should be rotated to level the horizon. With this accomplished, click OK. You will find that your horizon is now level, but the image is crooked. Now get the Crop tool and apply the crop without any rotation—and the horizon will be perfectly level!

With the cropping accomplished, and the image as you want it, it is now time to prepare your image for output.

13.
FILING AND OUTPUT: THE FINAL FRONTIER

When all of your digital manipulations have been made, there are two tasks that remain: filing and output.

While the manner in which you file your images is a very personal decision, your output requirements are largely determined by your client.

☐ FILING SYSTEMS

Image Identification. The first step in filing your images is to organize your digital files so that they can be easily identified and retrieved. Of course, there are a limited number of characters available for use in naming digital files. While I am sure there are several good systems that can be implemented, I use a numeric one that is usable over a period of years and is non-repeatable.

Here's my system: Each new client is identified by a four-digit number. The first two digits represent the year the client became my client, while the final numeral is a unique client number, sequentially assigned to all of my customers. For example, in 1996, my forty-sixth new client was #9646. The fifteenth new client in 2003 is #0315, and he or she will always retain that number. When that same client returns for another session, I add a hyphen and another number; for instance, files from the fourth sitting for client #0315 will be numbered #0315-04. Finally, each image from that shoot will also be numbered sequentially; the eleventh image is #0315-04-11. My clients' files are organized numerically in my database and are cross-listed alphabetically. As you can imagine, this system makes it easy to find the exact client, session, and even image that I am looking for.

WHEN ALL OF YOUR DIGITAL MANIPULATIONS HAVE BEEN MADE, THERE ARE TWO TASKS THAT REMAIN: FILING AND OUTPUT.

There are several programs that will help you to keep your files organized in your database. One of the most widely-used programs, Cumulus®, is available through www.canto.com.

□ STORAGE MEDIA

CDs and DVDs. A CD (see fig. 13.1) or DVD is currently the best storage device for digital files—they are the most stable, the least expensive (the cost of storage on a CD is currently less than half a cent per megabyte!) and, in the non-rewritable format, cannot be "erased"; for these reasons, they are often used to provide image files to clients.

I do not use the CD-RW (rewritable CDs) because they are considerably more expensive, rewriting is slow, and the data can be inadvertently lost. As standard non-rewritable (CD-R) disks are cheap, I write them and throw them away when they have served their purpose—but that's my personal opinion.

DVD DISKS HAVE THE SAME POTENTIAL PROBLEMS CDS DO, AND THEY COST ABOUT $4.00–$5.00 PER DISK.

figure 13.1

CD disks contain 700MB of storage space and are very reasonably priced. Looking for sales and rebates, you can actually get them for free! But the caveat here is that the cheaper they are (in most cases), the less stable they may be in the long run. The cheaper disks are expected to last no longer than ten years, and five years is the timeframe being touted for rewriting them. That is not a long time! The "archival" disks, or so they say, are supposed to be better and can usually be identified by their blue color—the bluer they are, the more archival. They usually

cost a dollar or more per disk. That puts the cost of storage at about 14¢ per megabyte. Not bad! Plus, everyone these days can read a CD if they have a newer computer!

DVD disks have the same potential problems CDs do, and they cost about $4.00–$5.00 per disk. But they contain 4.7 *gigabytes* of storage space, almost seven times that of a CD! That puts the cost per megabyte of storage at 10¢—less than a CD. If you can read *and* write DVDs, you've got a great storage device. However, many computers cannot read DVDs, so using them to provide images to your clients may not work. And who knows what the future holds for us in the area of storage and transport media?

When you write a CD for your office files, it is a good idea to make a second copy and store it off premise in case of fire or other disaster. They are not indestructible, and can even be lost. (Heck, they all look alike!) Making a backup copy is a cheap and painless way to achieve peace of mind.

When you burn an image to a disk for a client, you must remember to use either the JPEG or TIFF file format so that they can open them on their computers. Most word processing programs and imaging programs can open either of these files. TIFF files are best to retain

MAKING A BACKUP COPY IS A CHEAP AND PAINLESS WAY TO ACHIEVE PEACE OF MIND.

CONSIDER THIS...

The expected life span of a disk is touted to be ten years or less. However, some manufacturers are now promoting their disks as "archival," and while the cost is more, they are expected to last longer. What choice does that leave you? Well, you can set up a re-recording time schedule and copy the old disks to new ones. If you do this every five years, you should be fine. Or you can do nothing, because in five years, who knows what the latest and greatest storage device will be? Whatever your decision, there are several ways in which you can maximize the life of the disk:

• Do not write on them with a Sharpie-type marker. The alcohol base used to make them dry quickly will eventually destroy the storage layer of the disk.
• Do not put stick-on labels on the disks to identify them, as the glue in the labels will eventually destroy the storage layer.
• Use a special marking pen designed for use on CD/DVD disks. While they are considerably more expensive, they are supposed to eliminate any potential damage to the disk.

the most information but you must make sure that you *do not* save any layers, channels, paths, layers masks, etc. To ensure that your image files are client-friendly, be sure to flatten the files before burning the disks.

The biggest potential problem with this source of digital output is the loss of control. Once your files are delivered to a client, you must assume that they have neither a color calibrated monitor nor a profiled printer. This will mean that even though your output was correct, theirs most likely will not be and there will be a difference. This can cause a client to come back to you and complain about the color. You must explain to them *in advance* that this will happen so that you can prevent the problem before it happens.

Zip Disks. Zip disks (see fig 13.1 on page 109) represent another of the storage options available to photographers. The Zip 250 disk holds about 250 megabytes of information—a third of what one CD holds—and costs more than thirty times as much. While 750-megabyte disks are available, they are still expensive compared to CDs. Another disadvantage to using Zip disks is that they are easy to erase, so in using them, you run the risk of losing all of your images.

□ HARD COPY

There are several ways to output prints. Your options are outlined below.

Photographic Output. Photographic output on light-sensitive paper is normally done by a professional photo lab using printers that change digital input to analog output of light. The line of Kodak LED (the 20R, 30R, 20P and 30P models, often called "Pegasus") printers (which use light-emitting diodes) and the Fuji Frontier machines (which use RGB lasers that image directly to the photographic paper) are the most popular.

Dye Sublimation. This technology sublimates (transfers) cyan, magenta, and yellow dyes from a ribbon to a receiver paper, resulting in continuous-tone prints. These printers are relatively fast and produce good quality, archival photographs. While there are a wide variety of these printers available on the market, varying in size and cost, they are more expensive than the inkjet variety. Kodak produces a series of these printers.

Silver Halide/Dye Transfer. Fuji's Pictrography printers (see fig. 13.2 on page 112) use a silver halide process based on laser exposure and thermal development. Though still a dye transfer process, it is not the same as dye sublimation.

WHEN COMPARING VARIOUS MODELS, CONSIDER THE SPEED, COLOR, AND RESOLUTION EACH PRINTER OFFERS.

figure 13.2

Inkjet. By far the most popular do-it-yourself option, these printers spray tiny droplets of ink onto a paper substrate with a wide-ranging degree of resulting quality. The prices of these printers can range from under $100 to thousands of dollars. When comparing various models, consider the speed, color, and resolution each printer offers. The lowest-price models generally output photo-quality prints *very* slowly (it can take as long as fifteen minutes to print an 8x10-inch print), and may not offer the same amount of resolution that higher-priced units feature. One last consideration when choosing an inkjet printer is color. While this is a complicated topic, models with six or seven inks are generally better able to reproduce the subtleties in tone found in many portraits.

WHEN COMPARING VARIOUS MODELS, CONSIDER THE SPEED, COLOR, AND RESOLUTION EACH PRINTER OFFERS.

Laser Printers. While these printers process images quickly, they are much more adept at handling text than producing high-quality portraits. While top of the line laser printers offer reasonable quality images, dollar for dollar, inkjets are a better bet.

Giclée. There are a number of printers available on the market that spray tiny dots of rich, vibrant color onto paper (or canvas) that is attached to a spinning drum. The result? Fine art portraits called "Giclée." Prints from these machines can be made on standard matte or glossy paper, watercolor paper, or even on canvas. Many machines use rolled stock at least thirty-six inches wide, so photographers can output large, high-quality prints at reasonable prices.

☐ OUTSOURCE?

Film photographers have been working with print labs for years. With digital, the same options are available to you. Professional photo labs have always maintained high-quality equipment and trained operators to output your images from color or black & white negatives. Until recently, digital printing has not always produced a great print because labs have been gradually gearing themselves up to provide digital file reproduction. This is an expensive and somewhat tedious process for them and, as a result, the prints were of a less than acceptable quality. Add to that the fact that they were producing images based solely on what they received from the photographer without taking any responsibility for the end result. That is changing rapidly.

Many of the higher-quality labs are now asking their customers to send them digital files that have no, and I repeat, no color corrections made to the original files. While Photoshop is a wonderful tool, it can be a hammer when all that was needed was a toothpick. Less-than-qualified Photoshop users can quickly destroy the integrity of an image file, making it almost impossible for the lab to produce good color.

So how do you know what to do? It's simple . . . ask your lab how they want you to provide them with digital files, and then carefully follow their directions.

☐ IN HOUSE?

The do-it-yourself route's basis is in inkjet technology. With the advent of new archival color inks and paper, many photographers have found that it is in their best interests to do their output in-house. So far, only one printer manufacturer has really stepped up to the plate, providing high-quality, archival inkjet output at an affordable price: that is Epson.

Epson produces a large number of photographic quality printers, but their archival color pigment series is considered the way to go for printing your own images. The Epson 2200 (see fig. 13.3 on page 114) is a small, sheet-fed, desktop printer that produces 13x19-inch (Super A3) prints. They also offer two wide-carriage printers that use roll paper: the

WHILE PHOTOSHOP IS A WONDERFUL TOOL, IT CAN BE A HAMMER WHEN ALL THAT WAS NEEDED WAS A TOOTHPICK.

figure 13.3

figure 13.4

figure 13.5

7600 (24-inch) and 9600 (44-inch), depicted in image 13.4. They will produce large prints on several surfaces including glossy, luster, matte, and watercolor paper, as well as canvas. However, the downside of using wide-carriage printers is the use and cost of the RIP (Raster Image Processing) software. While you can "res up" your images in Photoshop, the RIP tends to do a better job. The ImagePrint RIP on the Epson 7600 printer produces absolutely beautiful, neutral black & white images. But figure on adding another $1,500 or so to the cost of the printers.

Epson's Gemini printers (fig. 13.5) are also available for those who do a large number of prints in a smaller size. Gemini printers are not available for sale. They must be leased from Epson, and the lease costs

EPSON'S GEMINI PRINTERS ARE ALSO AVAILABLE FOR THOSE WHO DO A LARGE NUMBER OF PRINTS IN A SMALLER SIZE.

are based on your monthly print output with a minimum cost requirement. But the prints are archival and the color is excellent.

The caveat with doing your own printing is that you are responsible for (meaning you absorb the cost of) any and all unacceptable prints. You need one of the professional-level profiling devices that will allow you to profile each of your printers and each of the types of paper you are going to use. Profiling is designed to produce a "profile" of the printer–ink–paper combinations and allow you to assign that profile to an image. Ideally this will give you a WYSIWYG (what you see is what you get) situation where the image on the monitor looks like what comes off the printer. Profiling is a tedious and time-consuming operation but necessary so as to minimize the number of unacceptable prints you produce, and this means a significant savings in time and money in the long run.

The Kodak dye sublimation printers and the Fuji Pictrography printers are also high-quality, archival output devices but are limited to smaller size prints, and they need to be profiled like the inkjet printers.

IF YOU SEND YOUR FILES TO A LAB, THEN YOU NEED TO USE THEIR PREFERRED METHOD OF CORRECTING COLOR.

■ COLOR MANAGEMENT

If you are printing your clients' portraits on your own inkjet printer, you need to make color corrections to suit your printer. If you send your files to a lab, then you need to use their preferred method of correcting color. All this is called "profiling" and that is the subject of another book—or series of books, actually. Establishing ICC profiles is a somewhat tedious task, but take heart—things are changing rapidly in the digital environment and hopefully soon we will not have nearly the problems that we have had to deal with for the past several years. In fact, the better labs are now doing color correction for client photographers, just like the labs have done for years with color negatives. What a concept!

■ GO OR NO GO?

The decision that each photographer must make is: Do you want to be a photo lab or not? If you want to have complete control over your output, in both time and quality, then you might consider doing your own printing. But you must understand that you will make a major commitment in both time and money, with money being the least of your considerations since the cost of the equipment and media is not overly expensive anymore. But do you want to or, more importantly, *can* you devote the time that it takes to do your own output? I can assure you that with any volume of output, you will need someone to do this por-

tion of your business for you. That person will need to know Photoshop and your equipment inside out in order to minimize time and money spent.

With the digital technology that's now available, there seems to be a new pressure on each of us to do our own printing, though most of us never did it before. What is it that compels us to meet the challenge now? Is it simply because we can?

Yes, there are major advantages to doing our own printing, but there are some major disadvantages, and you need to do your homework before you decide which approach is best for you. Put the numbers down on paper and look at them carefully. And remember, you most likely didn't do your own output when you used film, and you don't *have* to do it when you go digital!

APPENDIX

The keyboard shortcuts provided here appear throughout the text. This list will serve as a quick reference for readers interested in making quick work of selecting tools, filters, etc.

◻ TOOLBAR

Lasso tool—L

Move tool—V

Crop tool—C

Clone Stamp tool—S

Eraser tool—E

Brush tool—B

 Increase brush size—]

 Decrease brush size—[

 Increase brush hardness—Shift+]

 Increase brush softness—Shift+[

Healing Brush tool—J

History Brush tool—Y

◻ FILTERS

Liquify tools

Apply last filter used—Cmd/Ctrl+F

The following shortcuts may be applied when the tool dialogue box is open.

 Warp tool—W

 Turbulence tool—A

 Twirl Clockwise tool—R

 Twirl Counterclockwise tool—L

(Liquify tools, continued)

Pucker tool—P

Bloat tool—B

Shift Pixels tool—S

Reflection tool—M

Reconstruction tool—E

Freeze tool—F

Thaw tool —T

Zoom tool—Z

Hand tool —H

▢ COLOR BALANCE

Auto Contrast—Opt/Alt+Shift+Cmd/Ctrl+L

Auto Color—Shift+Cmd/Ctrl+B

Levels—Cmd/Ctrl+L

Curves—Cmd/Ctrl+M

Color Balance—Cmd/Ctrl B

Last Color Balance reading—Opt/Alt+Cmd/Ctrl+B

Hue/Saturation—Cmd/Ctrl+U

Desaturate—Shift+Cmd/Ctrl+U

▢ CLONE STAMP TOOL

The following shortcut may be applied when the tool is selected.

Opacity—use number keys

▢ EXTRACT TOOL

The following shortcuts may be applied when the tool dialogue box is open.

Edge Highlighter—B

Fill tool—G

Cleanup tool—C

Edge Touchup tool—T

▢ MISCELLANEOUS COMMANDS

Save—Cmd/Ctrl+S

100 percent screen view—Opt/Alt+Cmd/Ctrl+0

Background Copy—Cmd/Ctrl+J

The File Browser—Shift+Cmd/Ctrl+O

Cmd/Ctrl+Click to highlight then open multiple image files

INDEX

Outdoor and Location Portrait Photography
2nd Ed.

Jeff Smith

Learn to work with natural light, select locations, and make clients look their best. Packed with step-by-step discussions and illustrations to help you shoot like a pro! $29.95 list, 8½x11, 128p, 80 color photos, index, order no. 1632.

Infrared Photography Handbook

Laurie White

Covers black and white infrared photography: focus, lenses, film loading, film speed rating, batch testing, paper stocks, and filters. Black & white photos illustrate how IR film reacts. $29.95 list, 8½x11, 104p, 50 b&w photos, charts & diagrams, order no. 1419.

Leica Camera Repair Handbook

Thomas Tomosy

A detailed technical manual for repairing Leica cameras. Each model is discussed individually with step-by-step instructions. Exhaustive photographic illustration ensures that every step of the process is easy to follow. $39.95 list, 8½x11, 128p, 130 b&w photos, appendix, order no. 1641.

Creating World-Class Photography

Ernst Wildi

Learn how any photographer can create technically flawless photos. Features techniques for eliminating technical flaws in all types of photos—from portraits to landscapes. Includes the Zone System, digital imaging, and much more. $29.95 list, 8½x11, 128p, 120 color photos, index, order no. 1718.

Freelance Photographer's Handbook

Cliff and Nancy Hollenbeck

Whether you want to be a freelance photographer or are looking for tips to improve your current freelance business, this volume is packed with ideas for creating and maintaining a successful freelance business. $29.95 list, 8½x11, 107p, 100 b&w and color photos, index, glossary, order no. 1633.

The Beginner's Guide to Pinhole Photography

Jim Shull

Take pictures with a camera you make from stuff you have around the house. Develop and print the results at home! Pinhole photography is fun, inexpensive, educational and challenging. $17.95 list, 8½x11, 80p, 55 b&w photos, charts & diagrams, order no. 1578.

Infrared Landscape Photography

Todd Damiano

Landscapes shot with infrared can become breathtaking and ghostly images. The author analyzes over fifty of his compelling photographs to teach you the techniques you need to capture landscapes with infrared. $29.95 list, 8½x11, 120p, 60 b&w photos, index, order no. 1636.

Profitable Portrait Photography

Roger Berg

A step-by-step guide to making money in portrait photography. Combines information on portrait photography with detailed business plans to form a comprehensive manual for starting or improving your business. $29.95 list, 8½x11, 104p, 100 b&w and color photos, index, order no. 1570.

Wedding Photography
CREATIVE TECHNIQUES FOR LIGHTING AND POSING, *2nd Ed.*

Rick Ferro

Creative techniques for lighting and posing wedding portraits that will set your work apart from the competition. Covers every phase of wedding photography. $29.95 list, 8½x11, 128p, 80 color photos, index, order no. 1649.

Professional Secrets for Photographing Children
2nd Ed.

Douglas Allen Box

Covers every aspect of photographing children, from preparing them for the shoot, to selecting the right clothes to capture a child's personality, and shooting storybook themes. $29.95 list, 8½x11, 128p, 80 color photos, index, order no. 1635.

Handcoloring Photographs Step by Step

Sandra Laird and Carey Chambers

Learn to handcolor photographs step-by-step with the new standard in handcoloring reference books. Covers a variety of coloring media and techniques. $29.95 list, 8½x11, 112p, 100 b&w and color photos, order no. 1543.

Family Portrait Photography

Helen Boursier

Learn from professionals how to operate a successful studio. Includes: marketing family portraits, working with clients, posing, lighting, and selection of equipment. Includes images from a variety of top portrait shooters. $29.95 list, 8½x11, 120p, 120 b&w and color photos, index, order no. 1629.

The Art of Infrared Photography, *4th Ed.*

Joe Paduano

A practical guide to infrared photography. Tells what to expect and how to control results. Includes: anticipating effects, color infrared, digital infrared, using filters, focusing, developing, printing, handcoloring, toning, and more! $29.95 list, 8½x11, 112p, 70 b&w photos, order no. 1052.

Essential Skills for Nature Photography

Cub Kahn

Learn the skills you need to capture landscapes, animals, flowers, and the entire natural world on film. Includes: selecting equipment, choosing locations, evaluating compositions, filters, and much more! $29.95 list, 8½x11, 128p, 60 b&w and color photos, order no. 1652.

Photographer's Guide to Polaroid Transfer, *2nd Ed.*

Christopher Grey

Step-by-step instructions make it easy to master Polaroid transfer and emulsion lift-off techniques and add new dimension to your photographic imaging. Fully illustrated to ensure great results the first time! $29.95 list, 8½x11, 128p, 100 color photos, order no. 1653.

Black & White Landscape Photography

John Collett and David Collett

Master the art of black & white landscape photography. Includes: selecting equipment for landscape photography, shooting in the field, using the Zone System, and printing your images for professional results. $29.95 list, 8½x11, 128p, 80 b&w photos, order no. 1654.

Wedding Photojournalism

Andy Marcus

Learn to create dramatic unposed wedding portraits. Working through the wedding from start to finish, you'll learn where to be, what to look for, and how to capture it. $29.95 list, 8½x11, 128p, 60 b&w photos, order no. 1656.

Professional Secrets of Wedding Photography *2nd Ed.*

Douglas Allen Box

Top-quality portraits are analyzed to teach you the art of professional wedding portraiture. Lighting diagrams, posing information, and technical specs are included for every image. $29.95 list, 8½x11, 128p, 80 color photos, order no. 1658.

Photo Retouching with Adobe® Photoshop® *2nd Ed.*

Gwen Lute

Teaches every phase of the process, from scanning to final output. Learn to restore damaged photos, correct imperfections, create realistic composite images, and correct for dazzling color. $29.95 list, 8½x11, 120p, 100 color images, order no. 1660.

Creative Lighting Techniques for Studio Photographers, *2nd Ed.*

Dave Montizambert

Whether you are shooting portraits, cars, tabletop, or any other subject, Dave Montizambert teaches you the skills you need to take complete control of your lighting. $29.95 list, 8½x11, 120p, 80 color photos, order no. 1666.

Posing and Lighting Techniques for Studio Photographers

J. J. Allen

Master the skills you need to create beautiful lighting for portraits. Posing techniques for flattering, classic images help turn every portrait into a work of art. $29.95 list, 8½x11, 120p, 125 color photos, order no. 1697.

Corrective Lighting and Posing Techniques for Portrait Photographers

Jeff Smith

Learn to make every client look his or her best by using lighting and posing to conceal real or imagined flaws—from baldness, to acne, to figure flaws. $29.95 list, 8½x11, 120p, 150 color photos, order no. 1711.

Portrait Photographer's Handbook

Bill Hurter

Bill Hurter has compiled a step-by-step guide to portraiture that easily leads the reader through all phases of portrait photography. This book will be an asset to experienced photographers and beginners alike. $29.95 list, 8½x11, 128p, 100 color photos, order no. 1708.

Professional Marketing & Selling Techniques for Wedding Photographers

Jeff Hawkins and Kathleen Hawkins

Learn the business of wedding photography. Includes consultations, direct mail, advertising, internet marketing, and much more. $29.95 list, 8½x11, 128p, 80 color photos, order no. 1712.

Photographers and Their Studios

CREATING AN EFFICIENT AND PROFITABLE WORKSPACE

Helen T. Boursier

Tour professional studios and learn creative solutions for common problems. $29.95 list, 8½x11, 128p, 100 color photos, order no. 1713.

Photographing Creative Landscapes

Michael Orton

Boost your creativity and bring a new level of enthusiasm to your images of the landscape. This step-by-step guide is the key to escaping from your creative rut and beginning to create more expressive images. $29.95 list, 8½x11, 128p, 70 color photos, order no. 1714.

Advanced Infrared Photography Handbook

Laurie White Hayball

Building on the techniques covered in her *Infrared Photography Handbook*, Laurie White Hayball presents advanced techniques for harnessing the beauty of infrared light on film. $29.95 list, 8½x11, 128p, 100 b&w photos, order no. 1715.

Zone System

Brian Lav

Learn to create perfectly exposed black & white negatives and top-quality prints. With this step-by-step guide, anyone can learn the Zone System and gain complete control of their black & white images! $29.95 list, 8½x11, 128p, 70 b&w photos, order no. 1720.

Selecting and Using Classic Cameras

Michael Levy

Discover the charms and challenges of using classic cameras. Folders, TLRs, SLRs, Polaroids, rangefinders, spy cameras, and more are included in this gem for classic camera lovers. $17.95 list, 6x9, 196p, 90 b&w photos, order no. 1719.

Traditional Photographic Effects with Adobe® Photoshop®, 2nd Ed.

Michelle Perkins and Paul Grant

Use Photoshop to enhance your photos with handcoloring, vignettes, soft focus, and much more. Every technique contains step-by-step instructions for easy learning. $29.95 list, 8½x11, 128p, 150 color images, order no. 1721.

Master Posing Guide for Portrait Photographers

J. D. Wacker

Learn the techniques you need to pose single portrait subjects, couples, and groups for studio or location portraits. Includes techniques for photographing weddings, teams, children, special events and much more. $29.95 list, 8½x11, 128p, 80 photos, order no. 1722.

Photographic Lenses

PHOTOGRAPHER'S GUIDE TO CHARACTERISTICS, QUALITY, USE AND DESIGN

Ernst Wildi

Gain a complete understanding of the lenses through which all photographs are made—both on film and in digital photography. $29.95 list, 8½x11, 128p, 70 color photos, order no. 1723.

The Art of Color Infrared Photography

Steven H. Begleiter

Color infrared photography will open the doors to a new and exciting photographic world. This book shows readers how to previsualize the scene and get the results they want. $29.95 list, 8½x11, 128p, 80 color photos, order no. 1728.

The Art of Photographing Water

Cub Kahn

Learn to capture the interplay of light and water with this beautiful, compelling, and comprehensive book. Packed with practical information you can use right away! $29.95 list, 8½x11, 128p, 70 color photos, order no. 1724.

High Impact Portrait Photography

Lori Brystan

Learn how to create the high-end, fashion-inspired portraits your clients will love. Features posing, alternative processing, and much more. $29.95 list, 8½x11, 128p, 60 color photos, order no. 1725.

Legal Handbook for Photographers

Bert P. Krages, Esq.

This book offers examples that illustrate the *who, what, when, where* and *why* of problematic subject matter, putting photographers at ease to shoot without fear of liability. $19.95 list, 8½x11, 128p, 40 b&w photos, order no. 1726.

Digital Imaging for the Underwater Photographer

Jack and Sue Drafahl

This book will teach readers how to improve their underwater images with digital imaging techniques. This book covers all the bases—from color balancing your monitor, to scanning, to output and storage. $39.95 list, 6x9, 224p, 80 color photos, order no. 1727.

The Art of Bridal Portrait Photography

Marty Seefer

Learn to give every client your best and create timeless images that are sure to become family heirlooms. Seefer takes readers through every step of the bridal shoot, ensuring flawless results. $29.95 list, 8½x11, 128p, 70 color photos, order no. 1730.

Photographer's Filter Handbook

Stan Sholik and Ron Eggers

Take control of your photography with the tips offered in this book! This comprehensive volume teaches readers how to color-balance images, correct contrast problems, create special effects, and more. $29.95 list, 8½x11, 128p, 100 color photos, order no. 1731.

Beginner's Guide to Adobe® Photoshop®, *2nd Ed.*

Michelle Perkins

Learn to effectively make your images look their best, create original artwork, or add unique effects to any image. Topics are presented in short, easy-to-digest sections that will boost confidence and ensure outstanding images. $29.95 list, 8½x11, 128p, 300 color images, order no. 1732.

Professional Techniques for Digital Wedding Photography, *2nd Ed.*

Jeff Hawkins and Kathleen Hawkins

From selecting equipment, to marketing, to building a digital workflow, this book teaches how to make digital work for you. $29.95 list, 8½x11, 128p, 85 color images, order no. 1735.

Lighting Techniques for High Key Portrait Photography

Norman Phillips

Learn to meet the challenges of high key portrait photography and produce images your clients will adore. $29.95 list, 8½x11, 128p, 100 color photos, order no. 1736.

Photographer's Lighting Handbook

Lou Jacobs Jr.

Think you need a room full of expensive lighting equipment to get great shots? With a few simple techniques and basic equipment, you can produce the images you desire. $29.95 list, 8½x11, 128p, 130 color photos, order no. 1737.

Beginner's Guide to Digital Imaging

Rob Sheppard

Learn how to select and use digital technologies that will lend excitement and provide increased control over your images—whether you prefer digital capture or film photography. $29.95 list, 8½x11, 128p, 80 color photos, order no. 1738.

Professional Digital Photography

Dave Montizambert

From monitor calibration, to color balancing, to creating advanced artistic effects, this book provides those skilled in basic digital imaging with the techniques they need to take their photography to the next level. $29.95 list, 8½x11, 128p, 120 color photos, order no. 1739.

Group Portrait Photographer's Handbook

Bill Hurter

With images by top photographers, this book offers timeless techniques for composing, lighting, and posing group portraits. $29.95 list, 8½x11, 128p, 120 color photos, order no. 1740.

LIGHTING AND EXPOSURE TECHNIQUES FOR
Outdoor and Location Portrait Photography

J. J. Allen

Meet the challenges of changing light and complex settings with techniques that help you achieve great images every time. $29.95 list, 8½x11, 128p, 150 color photos, order no. 1741.

Toning Techniques for Photographic Prints

Richard Newman

Whether you want to age an image, provide a shock of color, or lend archival stability to your black & white prints, the step-by-step instructions in this book will help you realize your creative vision. $29.95 list, 8½x11, 128p, 150 color and b&w photos, order no. 1742.

The Art and Business of High School Senior Portrait Photography

Ellie Vayo

Learn the techniques that have made Ellie Vayo's studio one of the most profitable senior portrait businesses in the US. $29.95 list, 8½x11, 128p, 100 color photos, order no. 1743.

The Best of Nature Photography

Jenni Bidner and Meleda Wegner

Ever wondered how legendary nature photographers like Jim Zuckerman and John Sexton create their images? Follow in their footsteps as top photographers capture the beauty and drama of nature on film. $29.95 list, 8½x11, 128p, 150 color photos, order no. 1744.

Beginner's Guide to Nature Photography

Cub Kahn

Whether you prefer a walk through a neighborhood park or a hike through the wilderness, the beauty of nature is ever present. Learn to create images that capture the scene as you remember it with the simple techniques found in this book. $14.95 list, 6x9, 96p, 70 color photos, order no. 1745.

Photo Salvage with Adobe® Photoshop®

Jack and Sue Drafahl

This book teaches you to digitally restore faded images and poor exposures. Also covered are techniques for fixing color balance problems and processing errors, eliminating scratches, and much more. $29.95 list, 8½x11, 128p, 200 color photos, order no. 1751.

The Best of Wedding Photography

Bill Hurter

Learn how the top wedding photographers in the industry transform special moments into lasting romantic treasures with the posing, lighting, album design, and customer service pointers found in this book. $29.95 list, 8½x11, 128p, 150 color photos, order no. 1747.

Success in Portrait Photography

Jeff Smith

Many photographers realize too late that camera skills alone do not ensure success. This book will teach photographers how to run savvy marketing campaigns, attract clients, and provide top-notch customer service. $29.95 list, 8½x11, 128p, 100 color photos, order no. 1748.

Photographing Children with Special Needs

Karen Dórame

This book explains the symptoms of spina bifida, autism, cerebral palsy, and more, teaching photographers how to safely and effectively capture the unique personalities of these children. $29.95 list, 8½x11, 128p, 100 color photos, order no. 1749.

Professional Digital Portrait Photography

Jeff Smith

Because the learning curve is so steep, making the transition to digital can be frustrating. Author Jeff Smith shows readers how to shoot, edit, and retouch their images—while avoiding common pitfalls. $29.95 list, 8½x11, 128p, 100 color photos, order no. 1750.

The Best of Children's Portrait Photography

Bill Hurter

Rangefinder editor Bill Hurter draws upon the experience and work of top professional photographers, uncovering the creative and technical skills they use to create their magical portraits. $29.95 list, 8½x11, 128p, 150 color photos, order no. 1752.

Wedding Photography with Adobe® Photoshop®

Rick Ferro and Deborah Lynn Ferro

Get the skills you need to make your images look their best, add artistic effects, and boost your wedding photography sales with savvy marketing ideas. $29.95 list, 8½x11, 128p, 100 color images, index, order no. 1753.

Web Site Design for Professional Photographers

Paul Rose and Jean Holland-Rose

Learn to design, maintain, and update your own photography web site. Designed for photographers, this book shows you how to create a site that will attract clients and boost your sales. $29.95 list, 8½x11, 128p, 100 color images, index, order no. 1756.

PROFESSIONAL PHOTOGRAPHER'S GUIDE TO

Success in Print Competition

Patrick Rice

Learn from PPA and WPPI judges how you can improve your print presentations and increase your scores. $29.95 list, 8½x11, 128p, 100 color photos, index, order no. 1754.

Step-by-Step Digital Photography

Jack and Sue Drafahl

Avoiding the complexity and jargon of most manuals, this book will quickly get you started using your digital camera to create memorable photos. $14.95 list, 9x6, 112p, 185 color photos, index, order no. 1763.

Advanced Digital Camera Techniques

Jack and Sue Drafahl

Maximize the quality and creativity of your digital-camera images with the techniques in this book. Packed with problem-solving tips and ideas for unique images. $29.95 list, 8½x11, 128p, 150 color photos, index, order no. 1758.

PHOTOGRAPHER'S GUIDE TO

Wedding Album Design and Sales

Bob Coates

Enhance your income and creativity with these techniques from top wedding photographers. $29.95 list, 8½x11, 128p, 150 color photos, index, order no. 1757.

PROFESSIONAL TECHNIQUES FOR

Pet and Animal Photography

Debrah H. Muska

Adapt your portrait skills to meet the challenges of pet photography, creating images for both owners and breeders. $29.95 list, 8½x11, 128p, 110 color photos, index, order no. 1759.

The Best of Portrait Photography

Bill Hurter

View outstanding images from top professionals and learn how they create their masterful images. Includes techniques for classic and contemporary portraits. $29.95 list, 8½x11, 128p, 200 color photos, index, order no. 1760.

THE ART AND TECHNIQUES OF

Business Portrait Photography

Andre Amyot

Learn the business and creative skills photographers need to compete successfully in this challenging field. $29.95 list, 8½x11, 128p, 100 color photos, index, order no. 1762.

Creative Techniques for Color Photography

Bobbi Lane

Learn how to render color precisely, whether you are shooting digitally or on film. Also includes creative techniques for cross processing, color infrared, and more. $29.95 list, 8½x11, 128p, 250 color photos, index, order no. 1764.

The Bride's Guide to Wedding Photography

Kathleen Hawkins

Learn how to get the wedding photography of your dreams with tips from the pros. Perfect for brides or wedding photographers who want their clients to look their best. $14.95 list, 9x6, 112p, 115 color photos, index, order no. 1755.

The Best of Teen and Senior Portrait Photography

Bill Hurter

Learn how top professionals create stunning images that capture the personality of their teen and senior subjects. $29.95 list, 8½x11, 128p, 150 color photos, index, order no. 1766.

The Portrait Book

A GUIDE FOR PHOTOGRAPHERS

Steven H. Begleiter

A comprehensive textbook for those getting started in professional portrait photography. Covers every aspect from designing an image to executing the shoot. $29.95 list, 8½x11, 128p, 130 color images, index, order no. 1767.

The Master Guide for Wildlife Photographers

Bill Silliker, Jr.

Discover how photographers can employ the techniques used by hunters to call, track, and approach animal subjects. Includes safety tips for wildlife photo shoots. $29.95 list, 8½x11, 128p, 100 color photos, index, order no. 1768.

Heavenly Bodies

THE PHOTOGRAPHER'S GUIDE TO ASTROPHOTOGRAPHY

Bert P. Krages, Esq.

Learn to capture the beauty of the night sky with a 35mm camera. Tracking and telescope techniques are also covered. $29.95 list, 8½x11, 128p, 100 color photos, index, order no. 1769.

Digital Photography for Children's and Family Portraiture

Kathleen Hawkins

Discover how digital photography can boost your sales, enhance your creativity, and improve your studio's workflow. $29.95 list, 8½x11, 128p, 130 color images, index, order no. 1770.

Professional Strategies and Techniques for Digital Photographers

Bob Coates

Learn how professionals—from portrait artists to commercial specialists—enhance their images with digital techniques. $29.95 list, 8½x11, 128p, 130 color photos, index, order no. 1772.

Lighting Techniques for Low Key Portrait Photography

Norman Phillips

Learn to create the dark tones and dramatic lighting that typify this classic portrait style. $29.95 list, 8½x11, 128p, 100 color photos, index, order no. 1773.

The Best of Wedding Photojournalism

Bill Hurter

Learn how top professionals capture these fleeting moments of laughter, tears, and romance. Features images from over twenty renowned wedding photographers. $29.95 list, 8½x11, 128p, 150 color photos, index, order no. 1774.

The Digital Darkroom Guide with Adobe® Photoshop®

Maurice Hamilton

Bring the skills and control of the photographic darkroom to your desktop with this complete manual. $29.95 list, 8½x11, 128p, 140 color images, index, order no. 1775.

Color Correction and Enhancement with Adobe® Photoshop®

Michelle Perkins

Master precision color correction and artistic color enhancement techniques for scanned and digital photos. $29.95 list, 8½x11, 128p, 300 color images, index, order no. 1776.

Fantasy Portrait Photography

Kimarie Richardson

Learn how to create stunning portraits with fantasy themes—from fairies and angels, to 1940s glamour shots. Includes portrait ideas for infants through adults. $29.95 list, 8½x11, 128p, 60 color photos index, order no. 1777.